Jargon 76

THE FAMILY ALBUM OF LUCYBELLE CRATER

The family album of
LUCYBELLE CRATER

RALPH EUGENE MEATYARD

With texts by
Jonathan Greene, Ronald Johnson,
Ralph Eugene Meatyard, Guy Mendes, Thomas Meyer,
and Jonathan Williams

THE JARGON SOCIETY

Jonathan Williams
and The Jargon Society
wish to thank

Wendell Berry
Guy Davenport
Jonathan Greene
James Baker Hall
Michael Hoffman
Ronald Johnson
Robert C. May
Madelyn Meatyard
Guy Mendes
Thomas Meyer
Donald B. Anderson
The Mary Duke Biddle Foundation
The National Endowment for the Arts
and several private contributors
whose advice, work, and support
have made this book possible.

Copyright © 1974 by Madelyn Meatyard
Library of Congress Catalog Card Number: 74-76773
SBN: 912330-02-3 Cloth
SBN: 912330-03-1 Paperback
Designed by Dave Epstein

165760

Distributed by
The Book Organization
Elm Street
Millerton, New York 12546

Mask (Fr. *masque*, apparently from med. Lat. *mascus*, *masca*, spectre, through Ital. *maschera*, Span. *mascara*), a covering for the face, taking various forms, used either as a protective screen or as a disguise . . .
—*Encyclopaedia Britannica* (Eleventh Edition)

Lucybelle Crater and her 46-year-old husband Lucybelle Crater

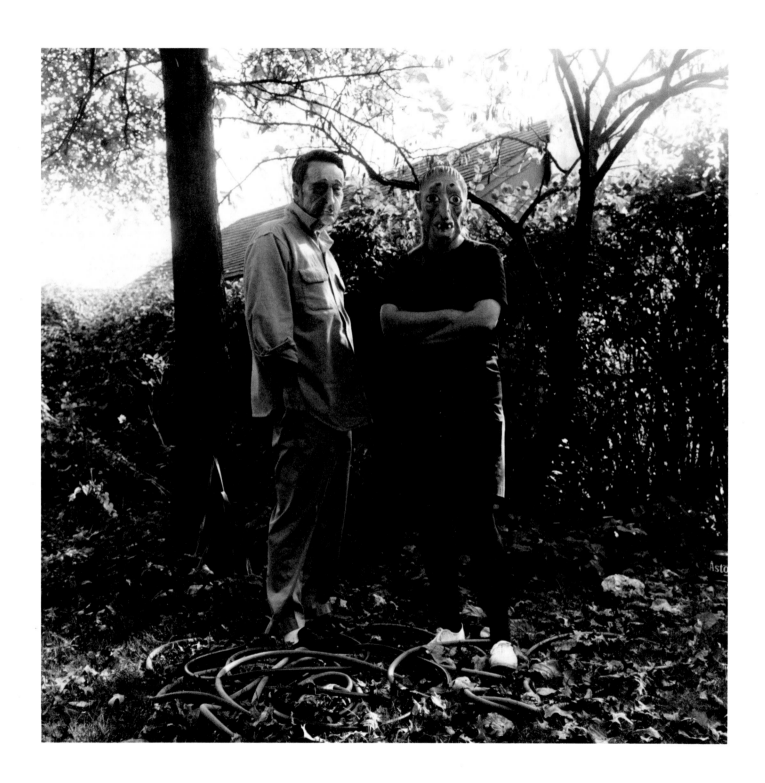

7

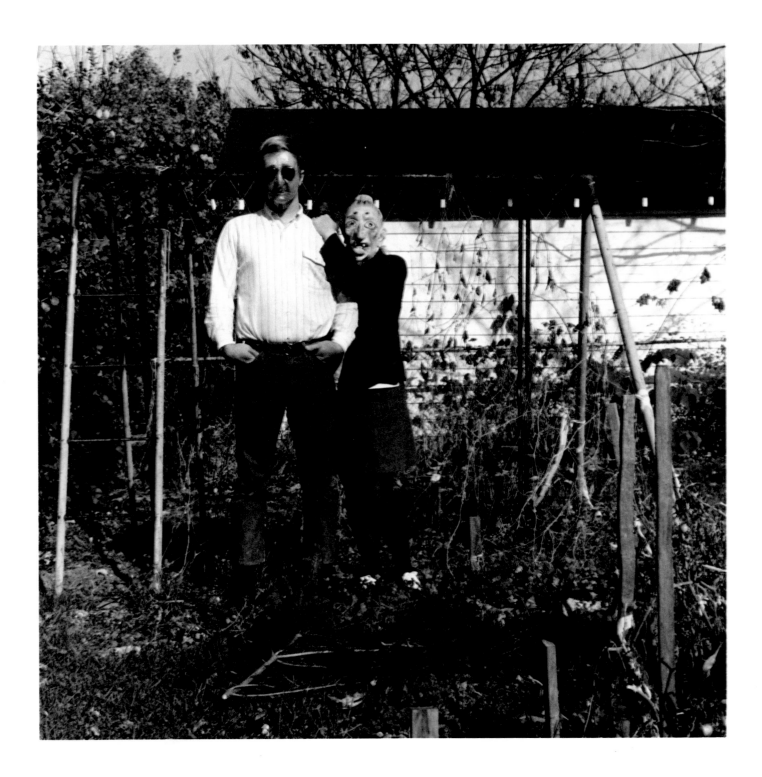

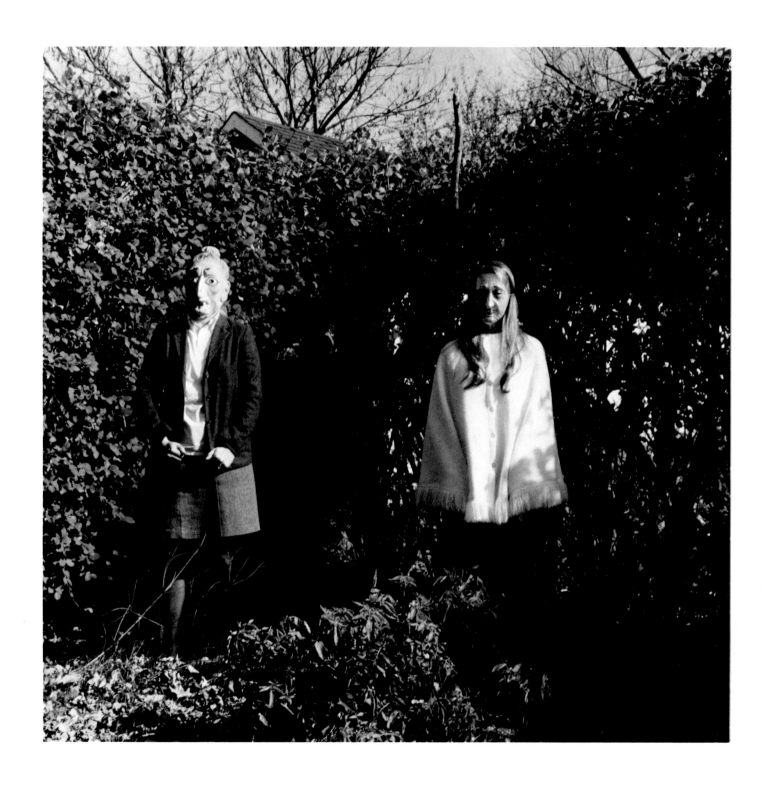

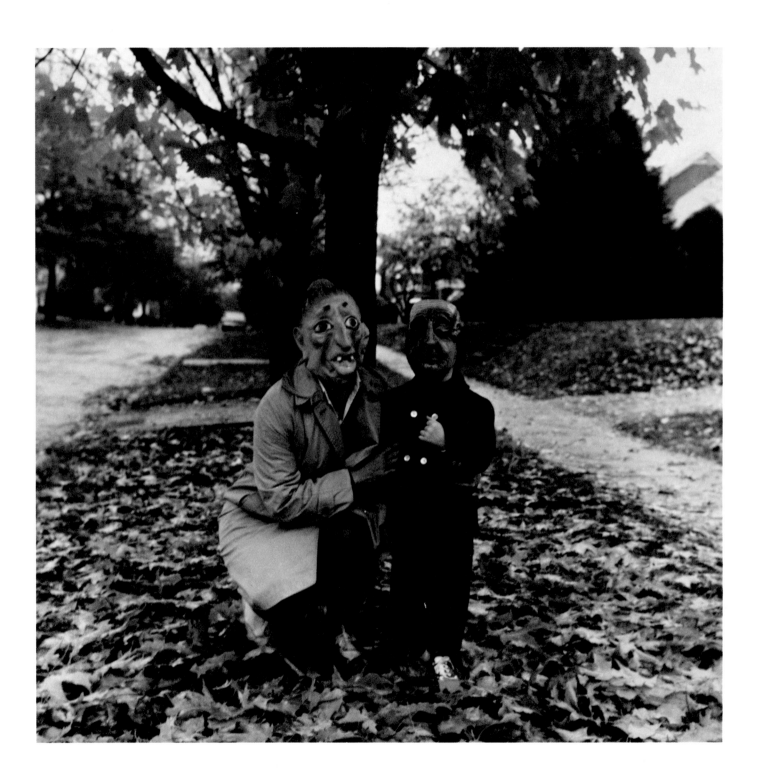

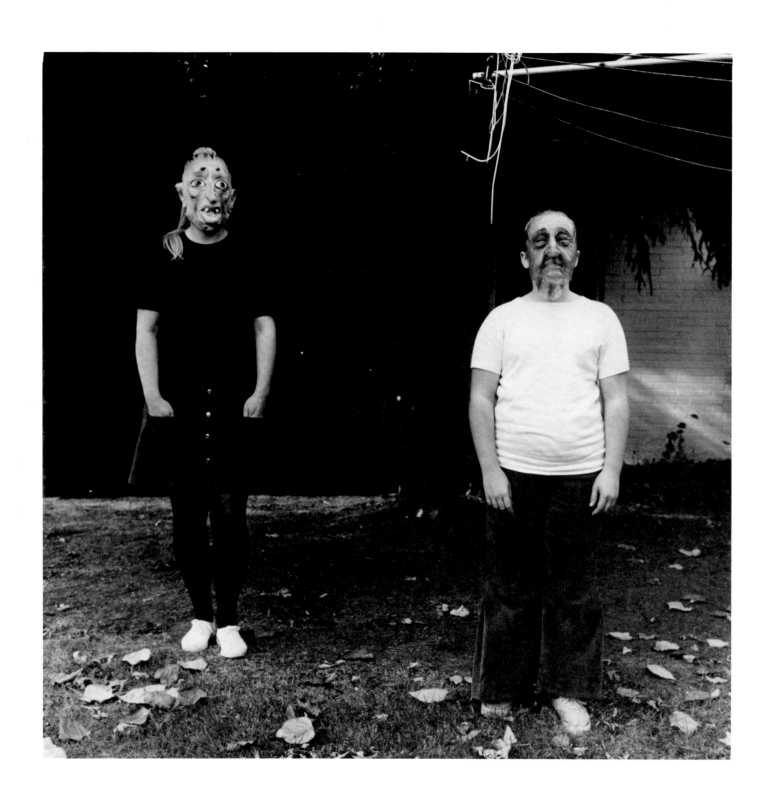

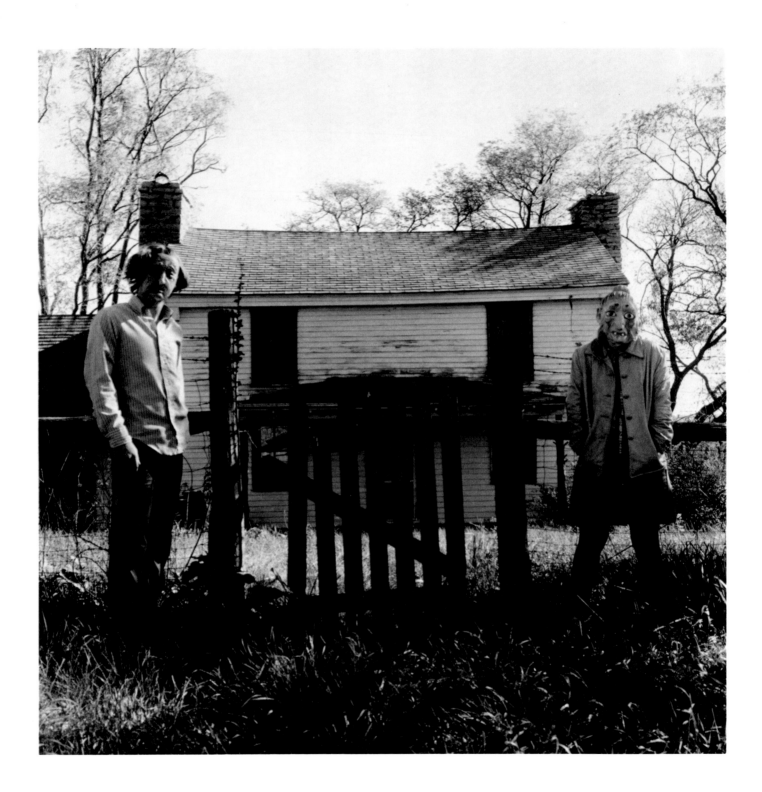

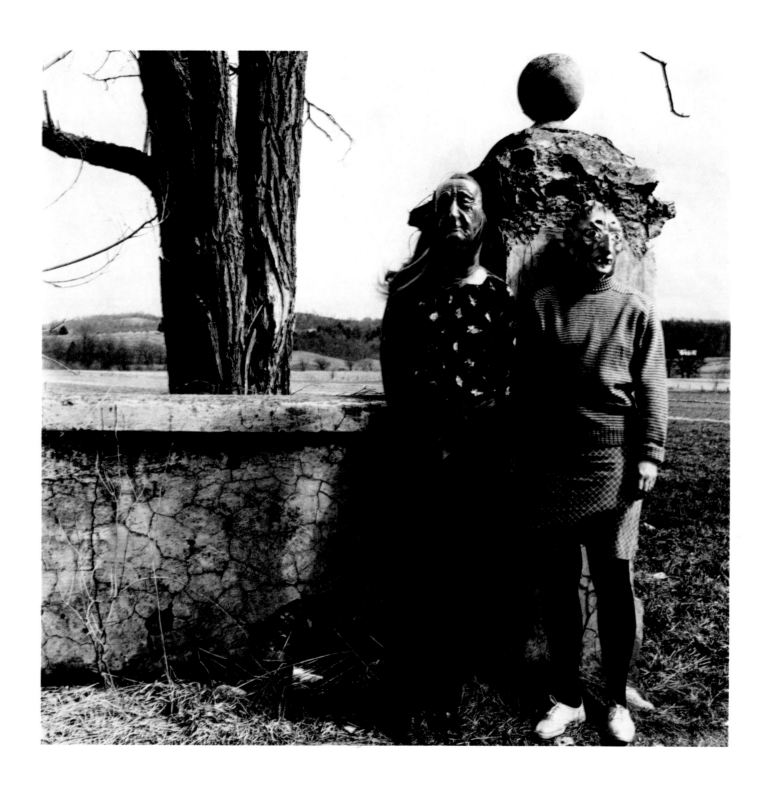

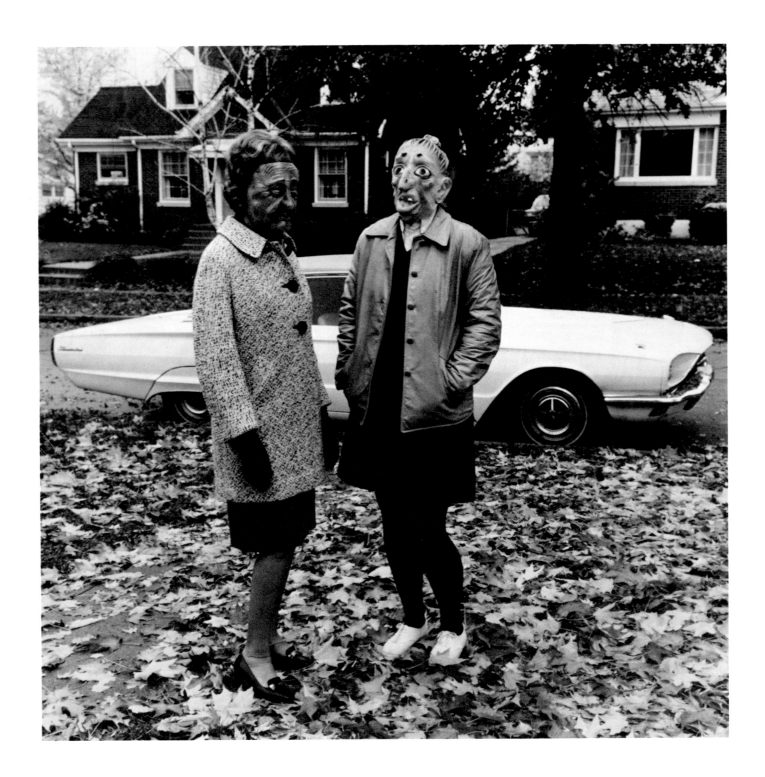

14

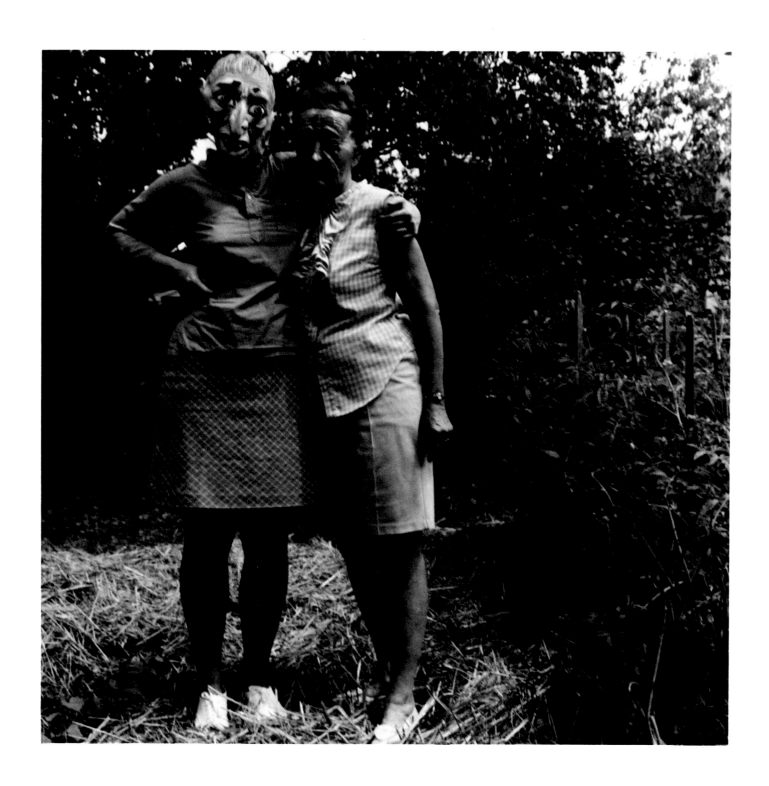

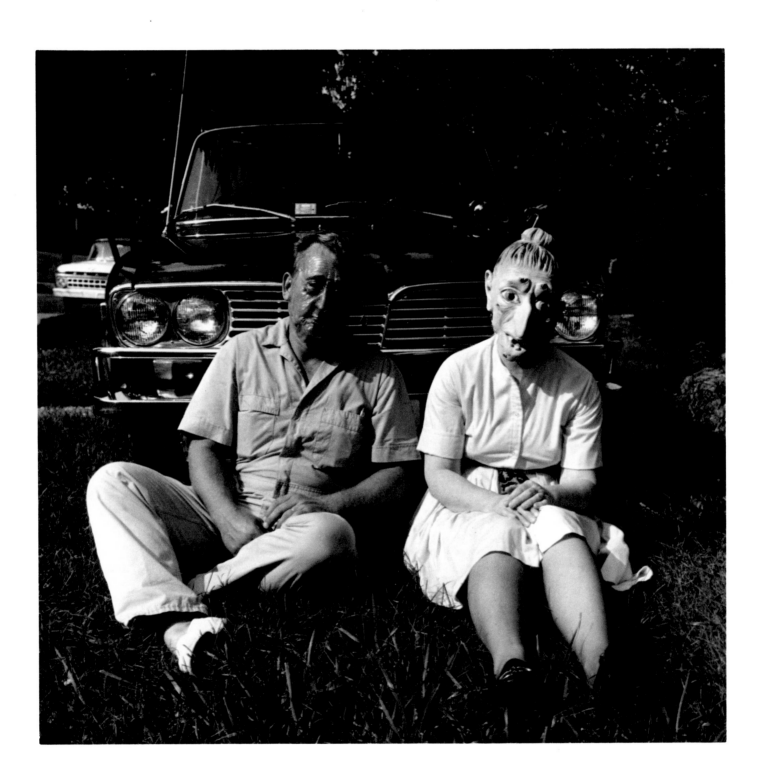

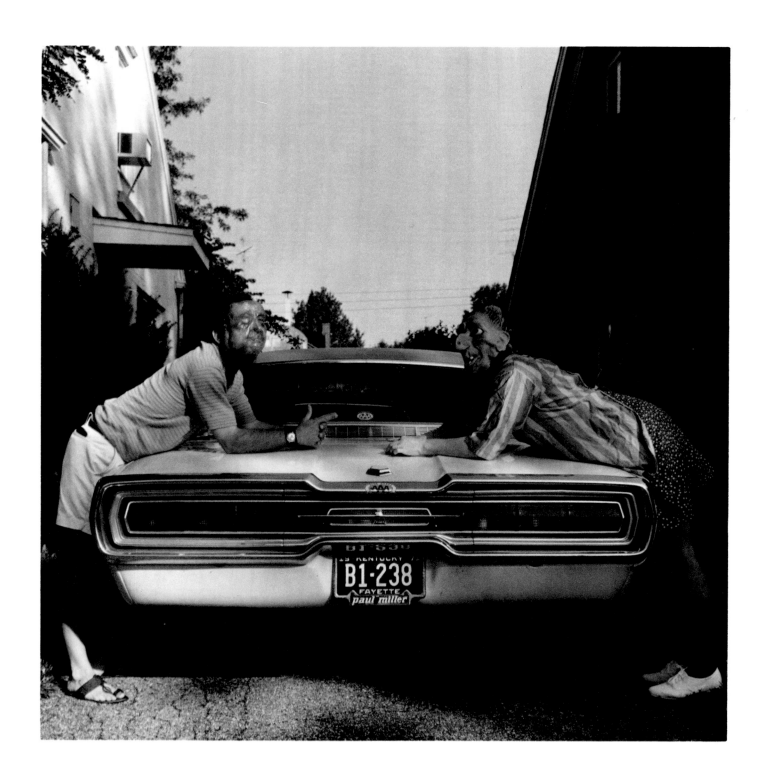

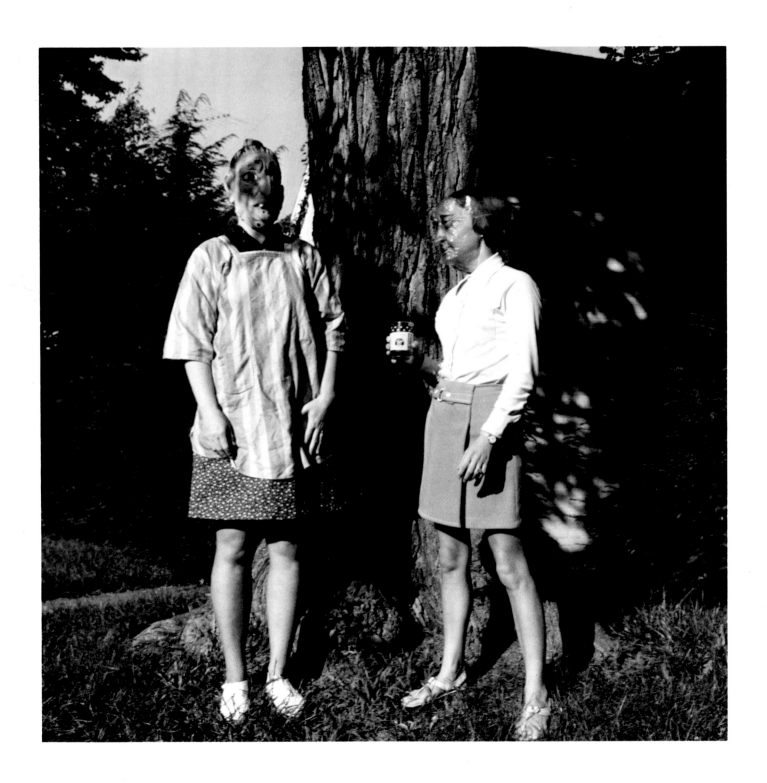

18

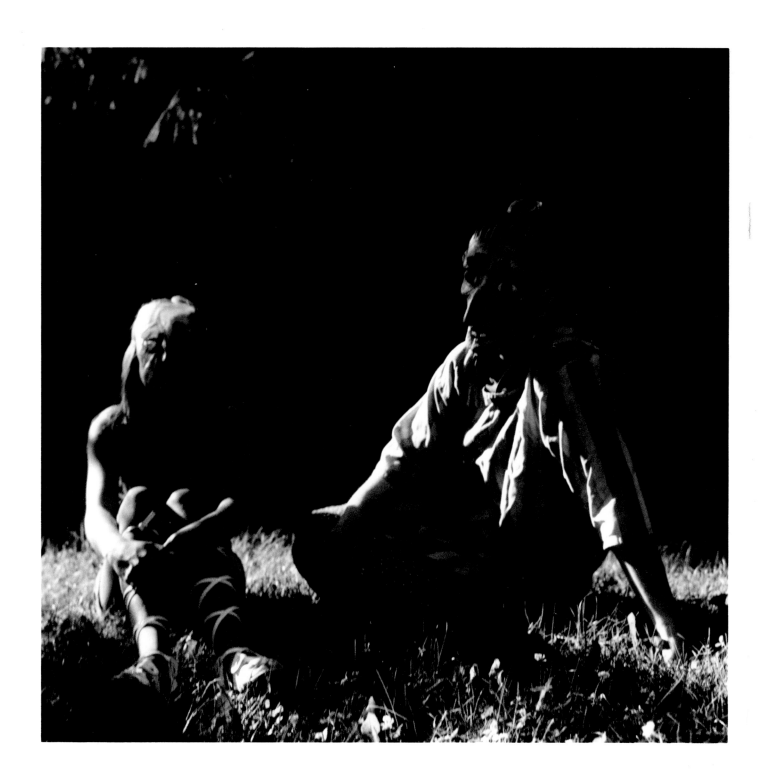

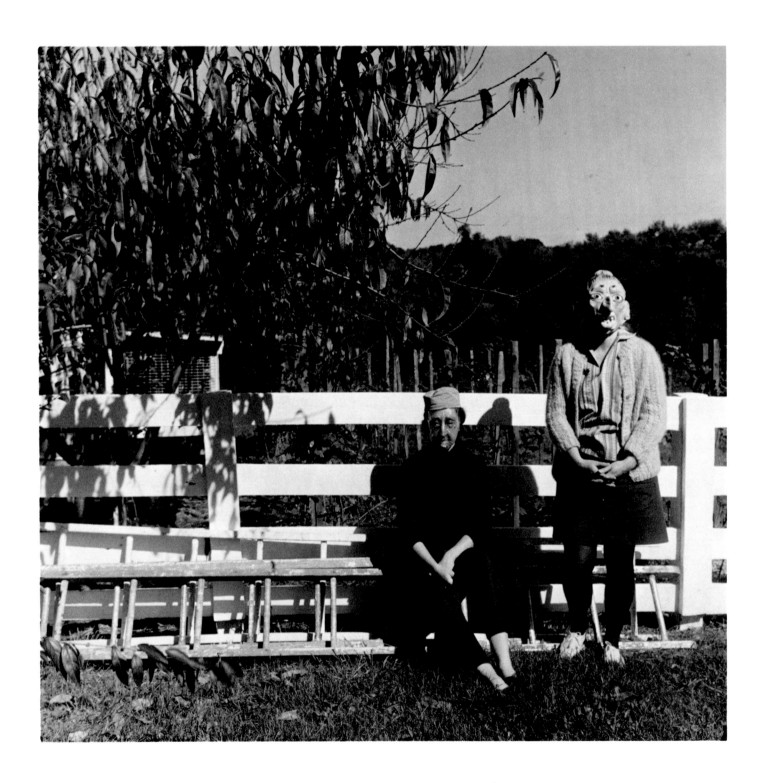

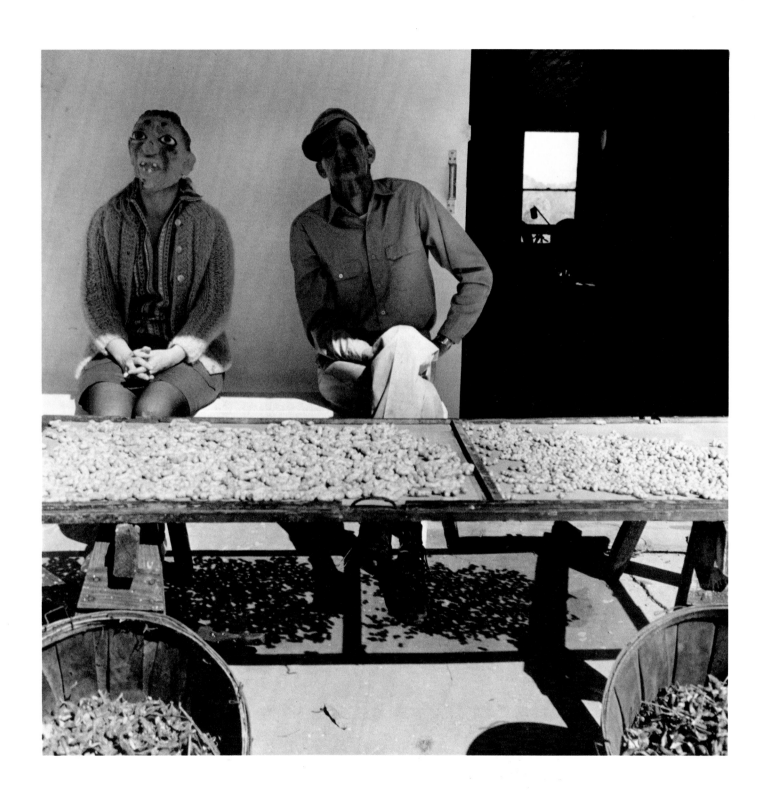

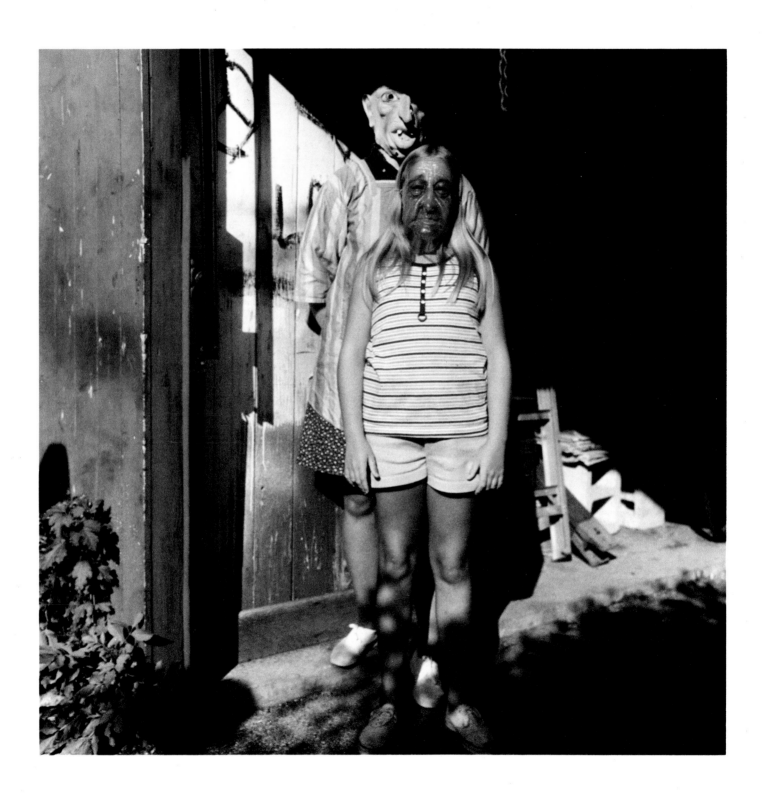

22

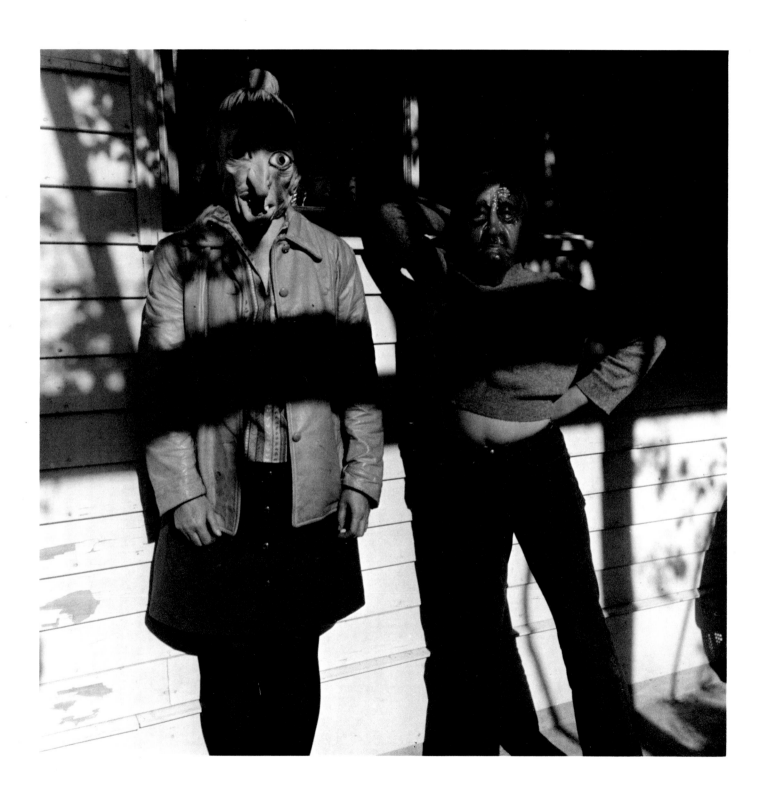

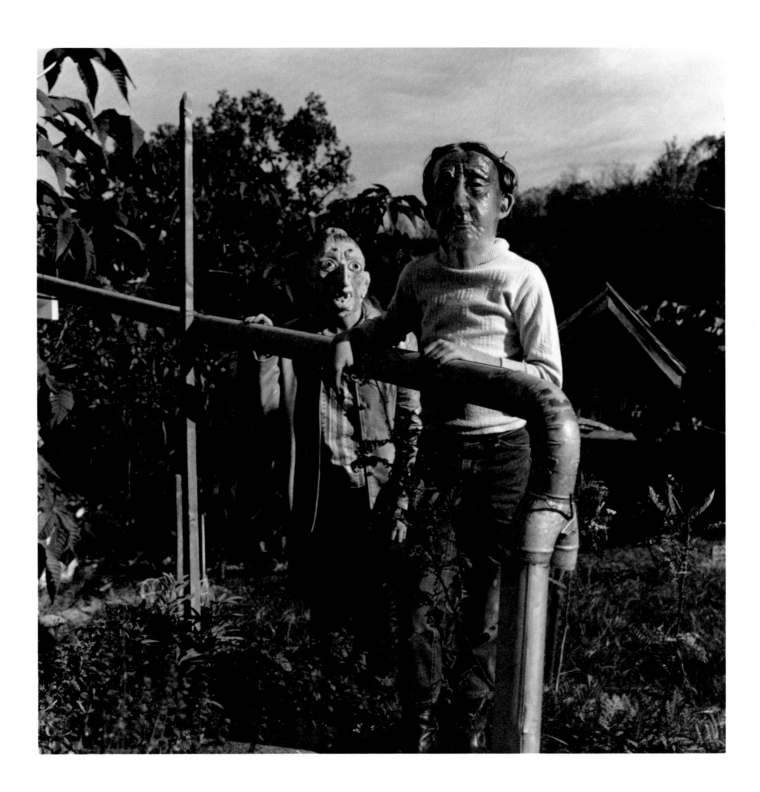

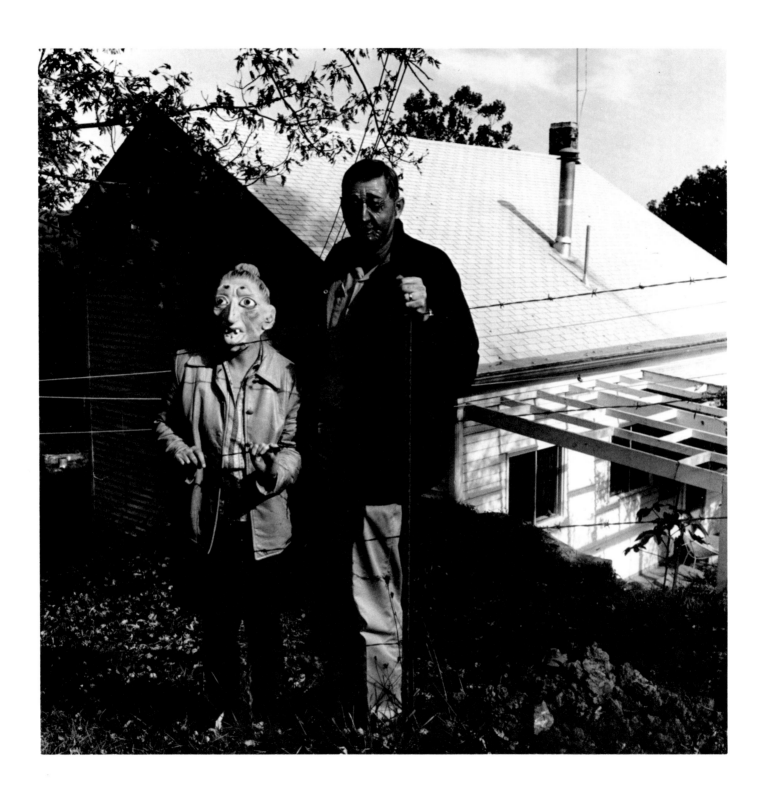

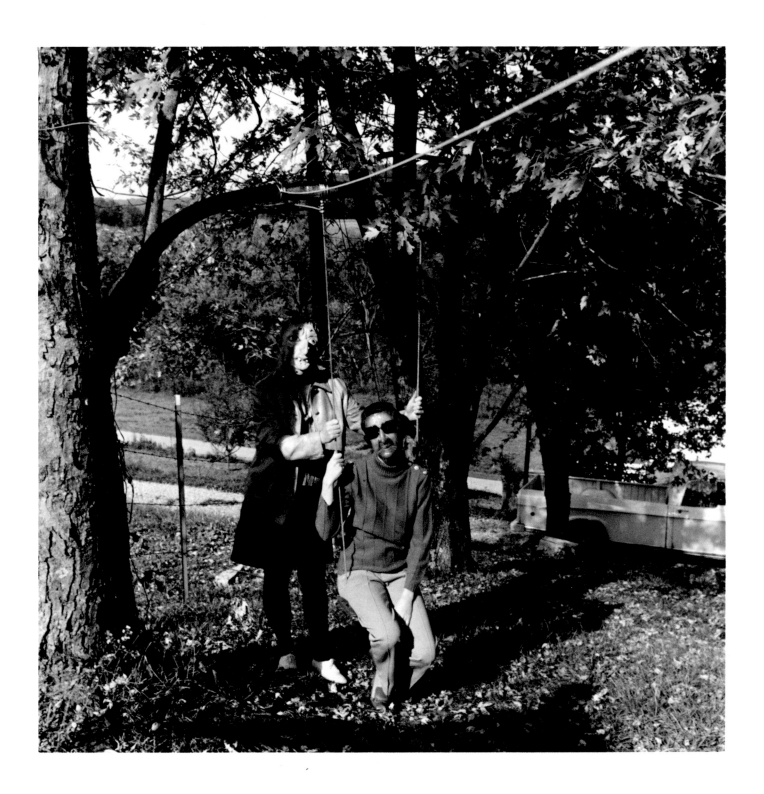

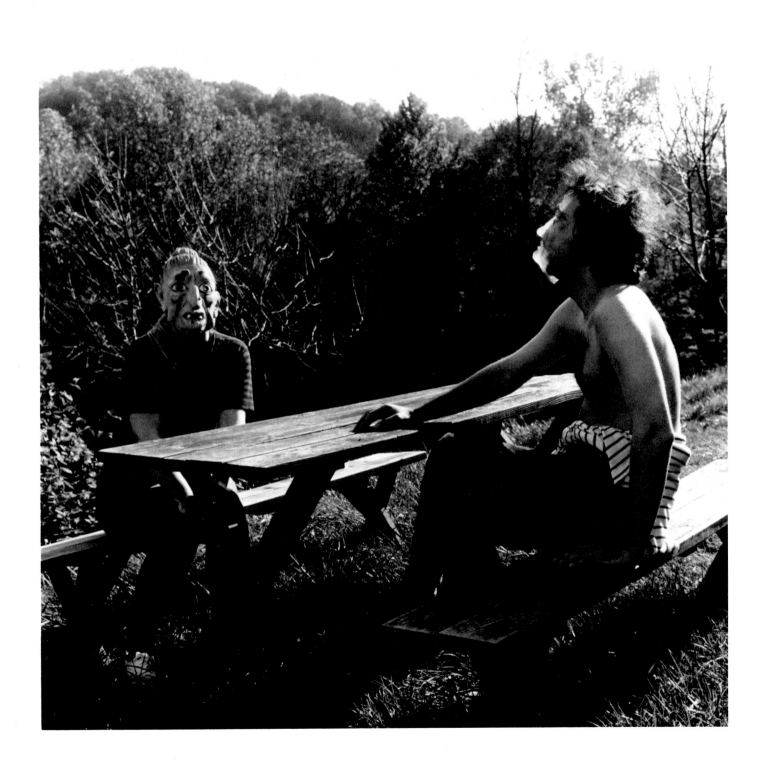

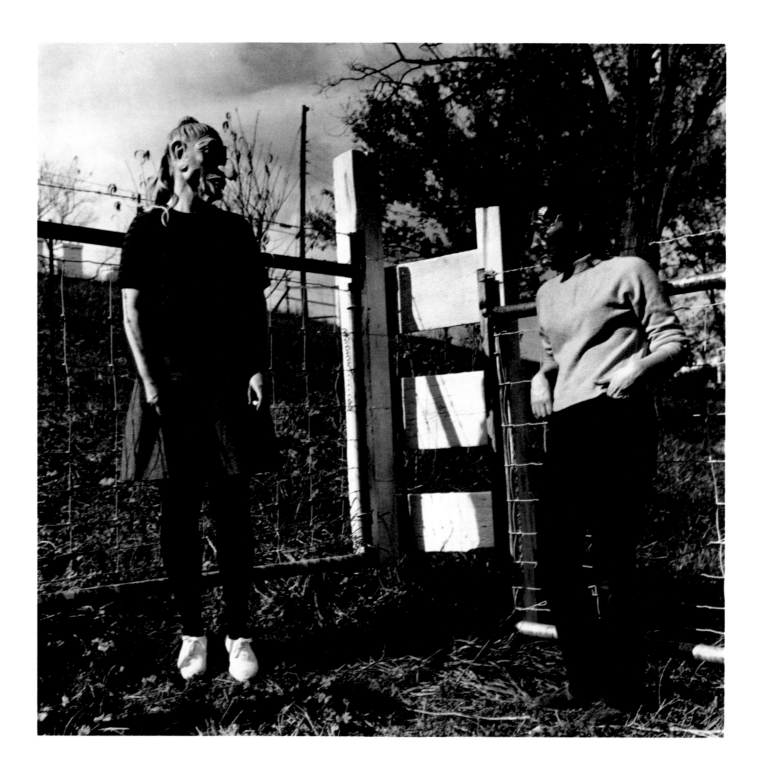

28

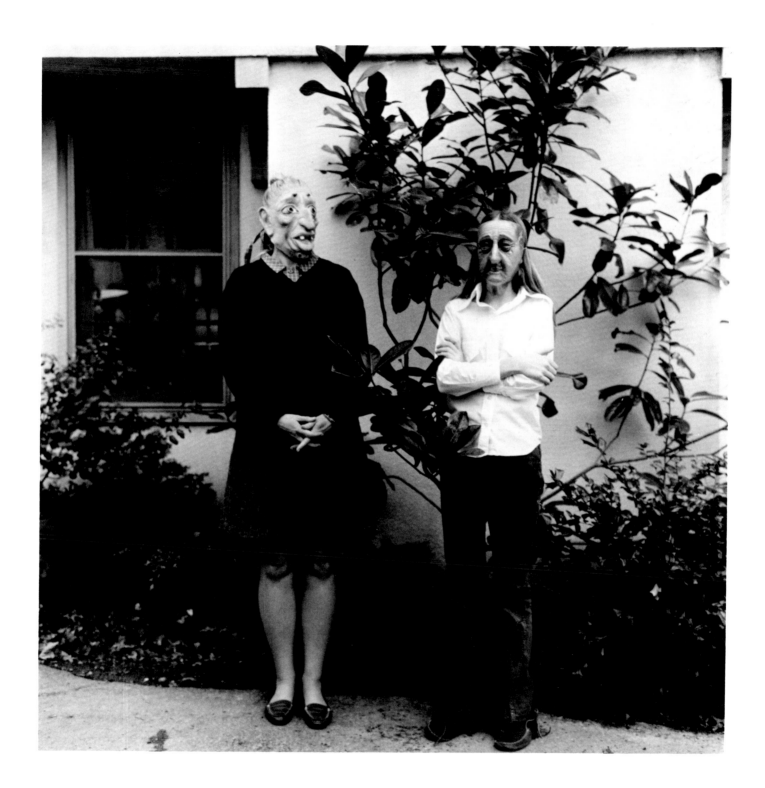

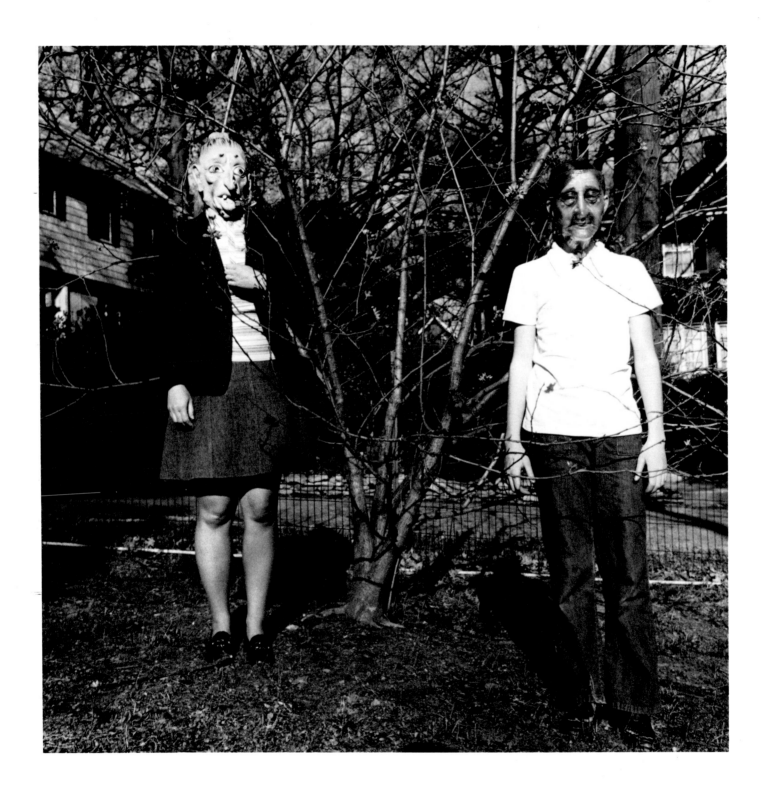

34

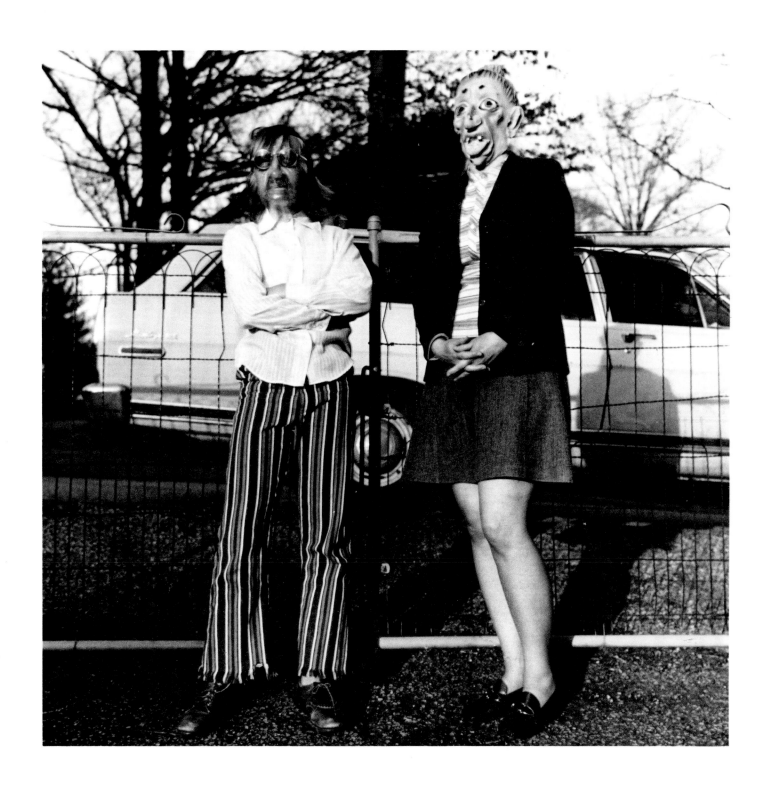

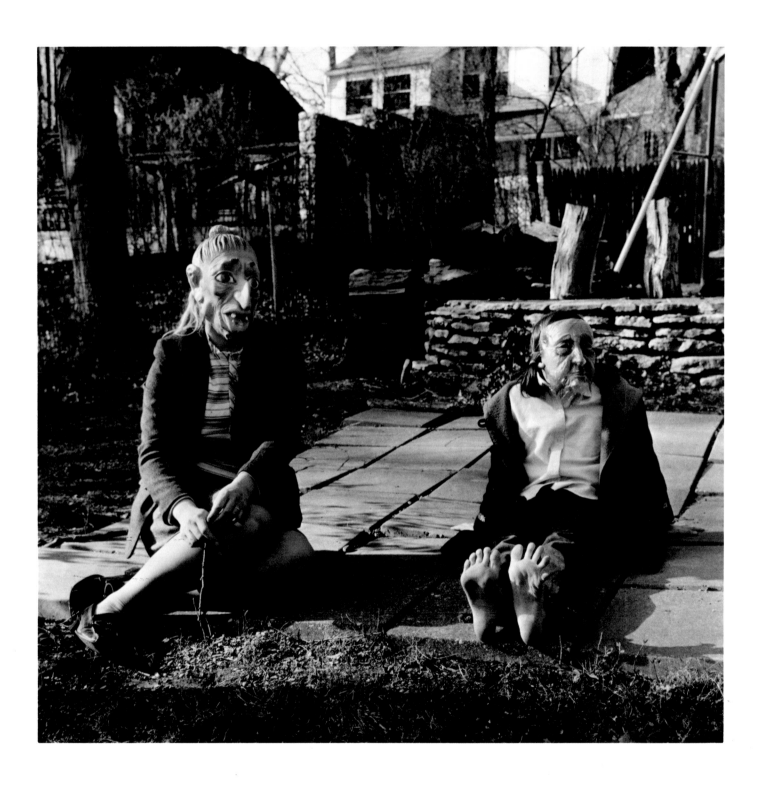

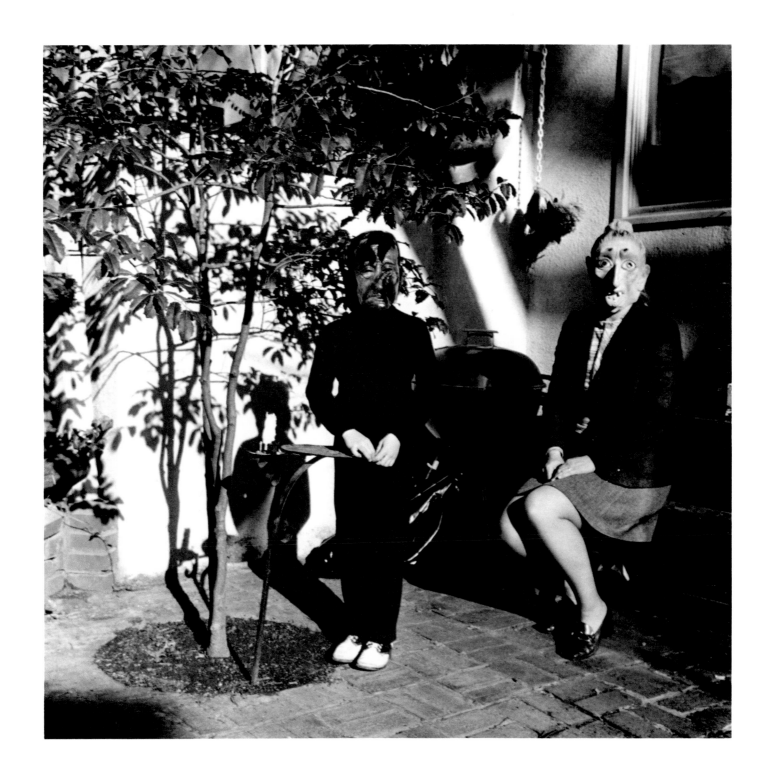

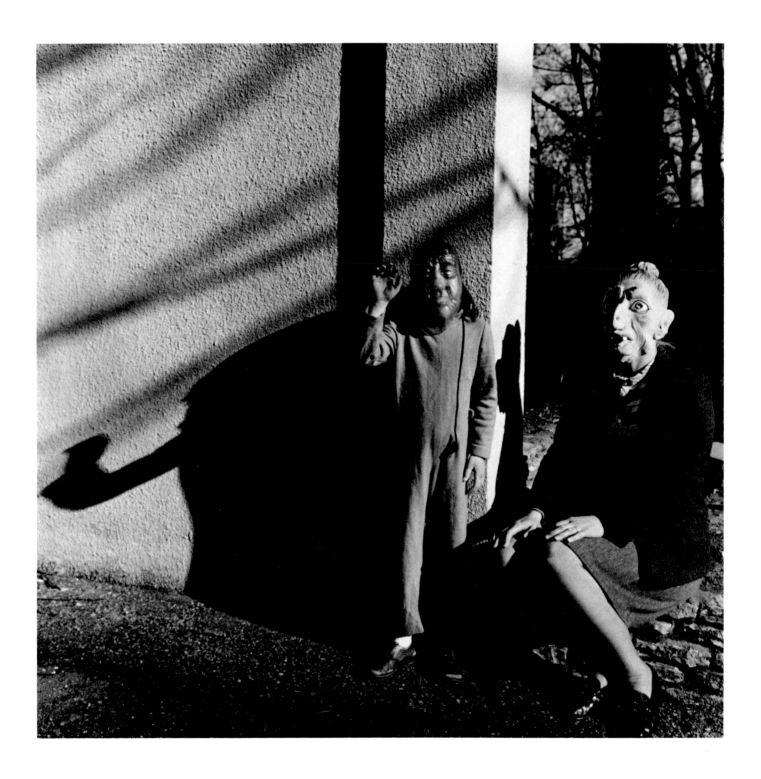

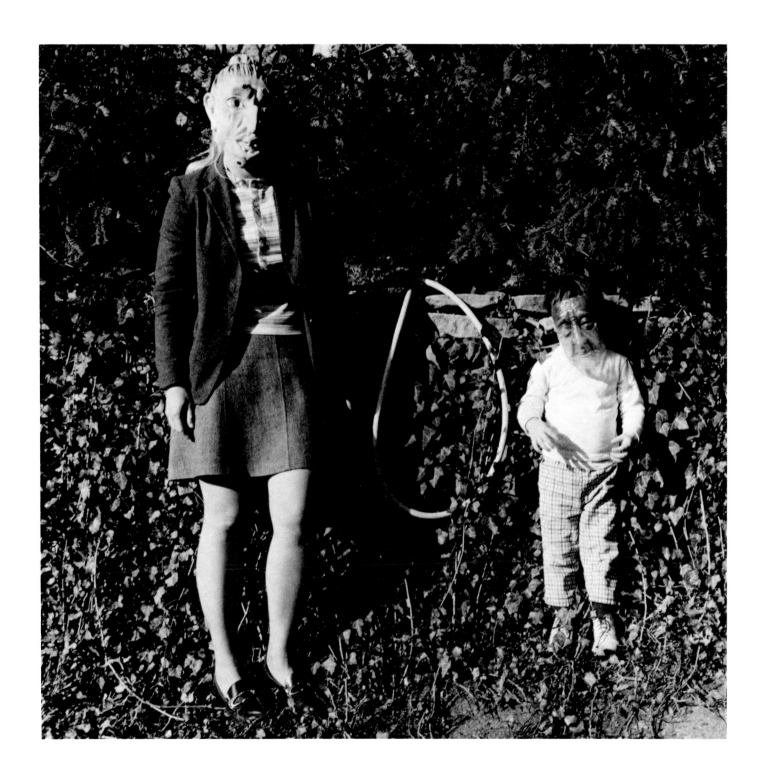

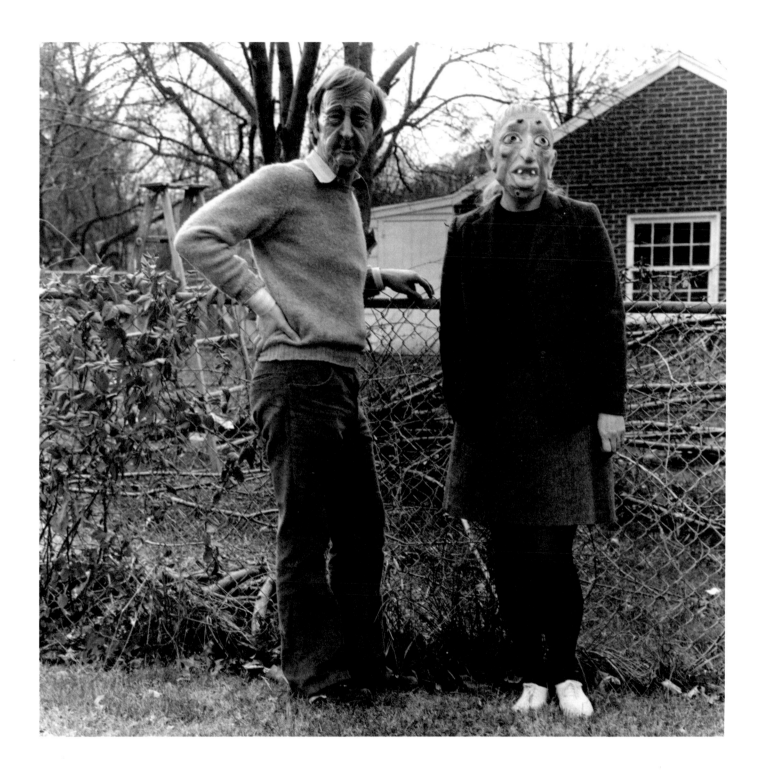

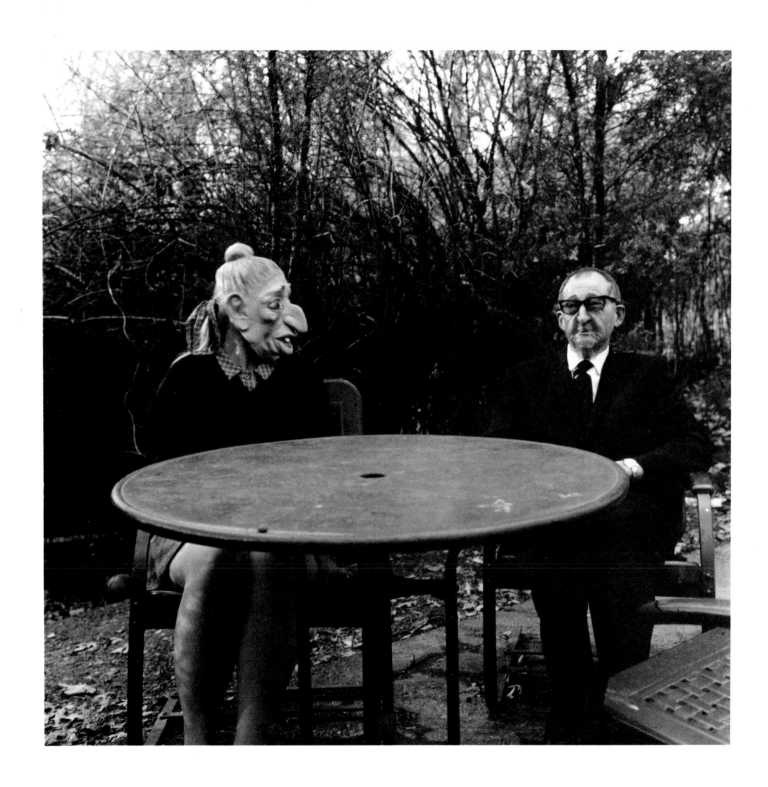

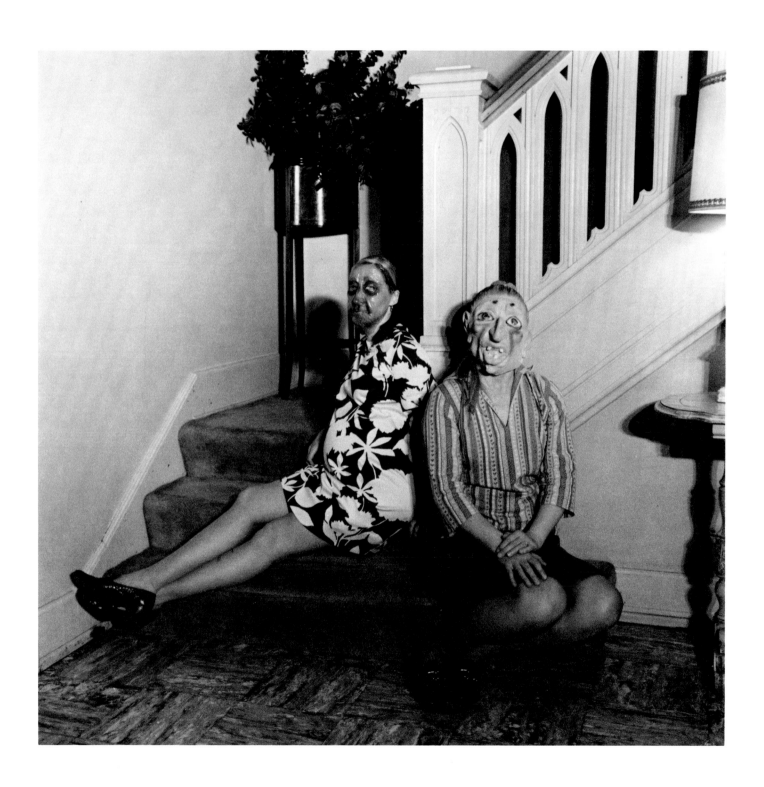

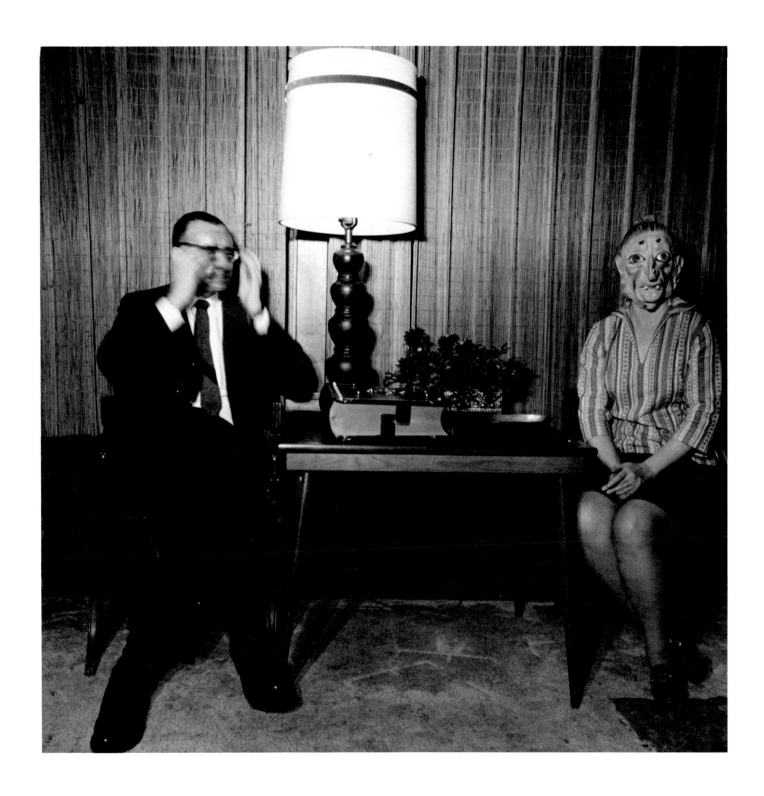

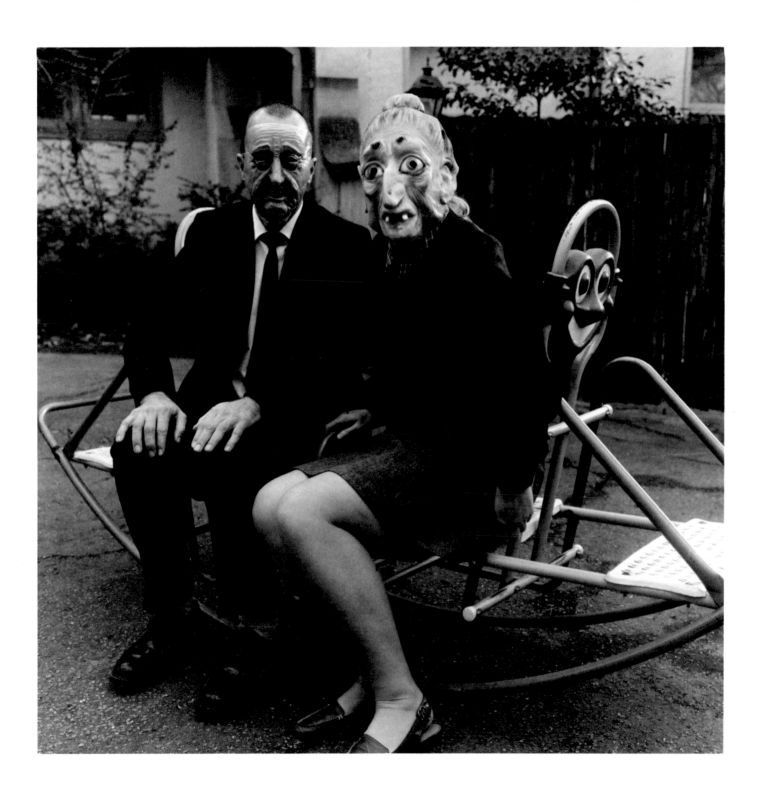

44

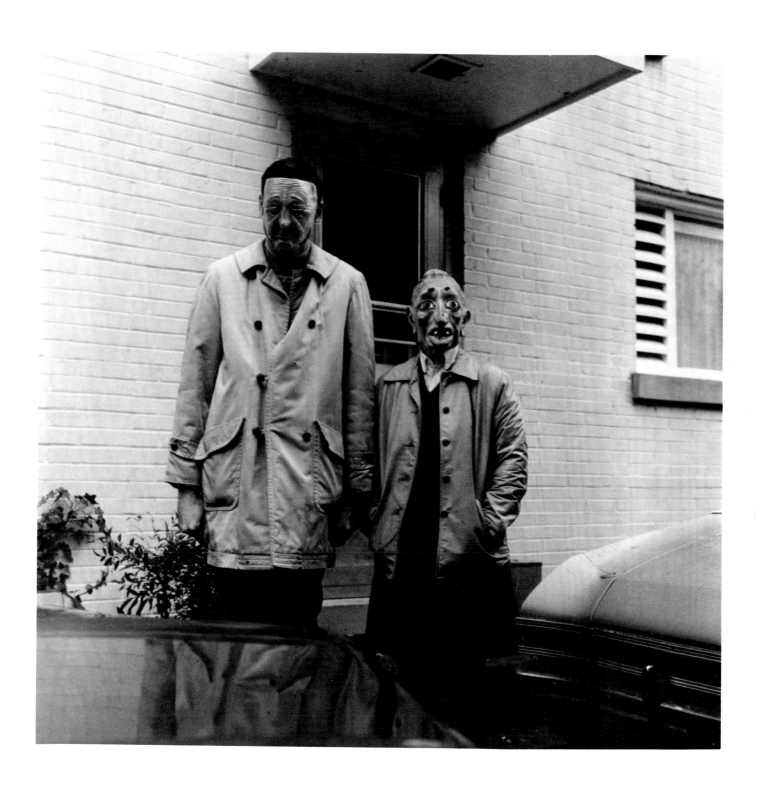

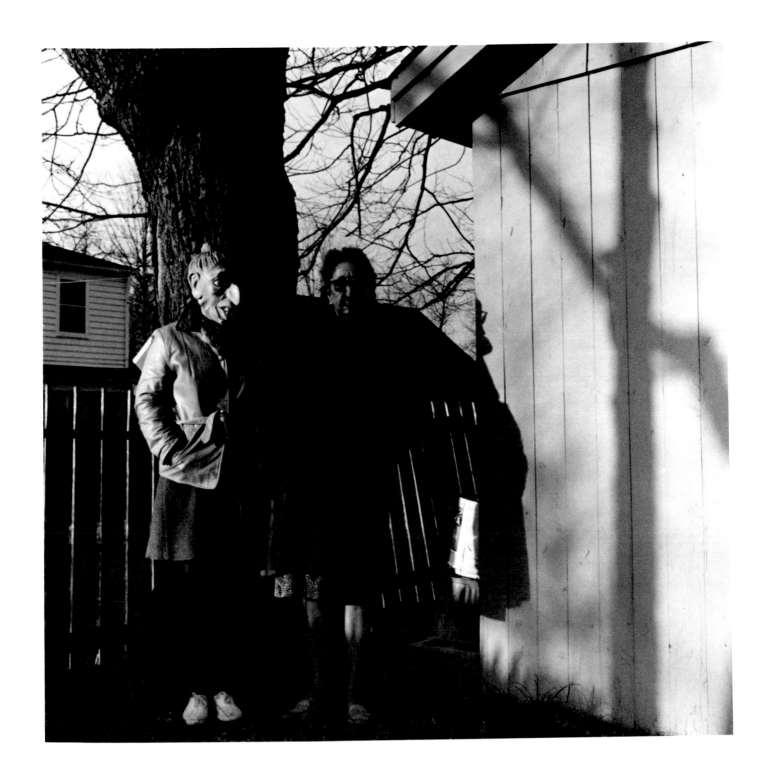

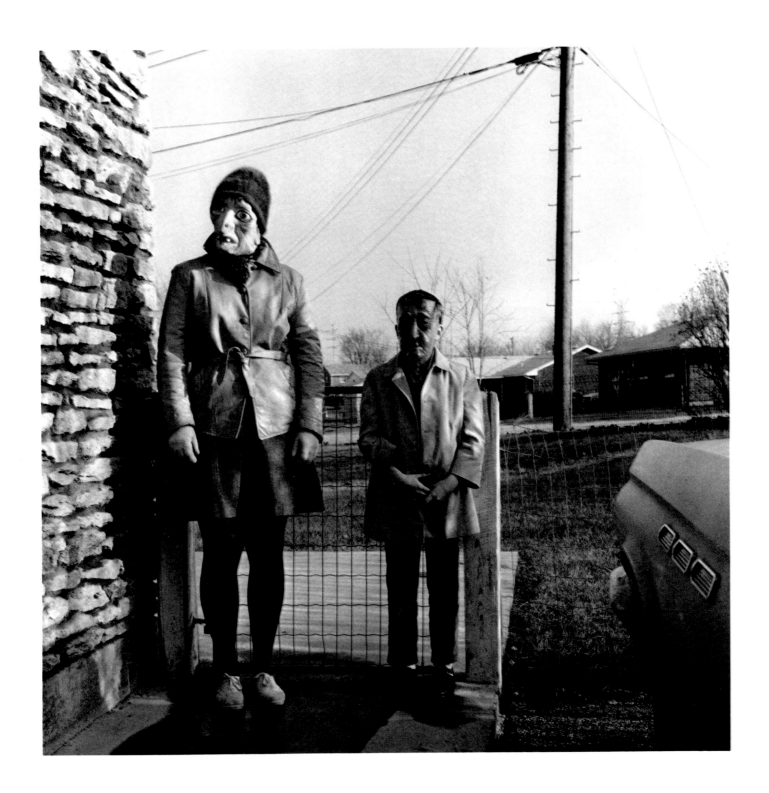

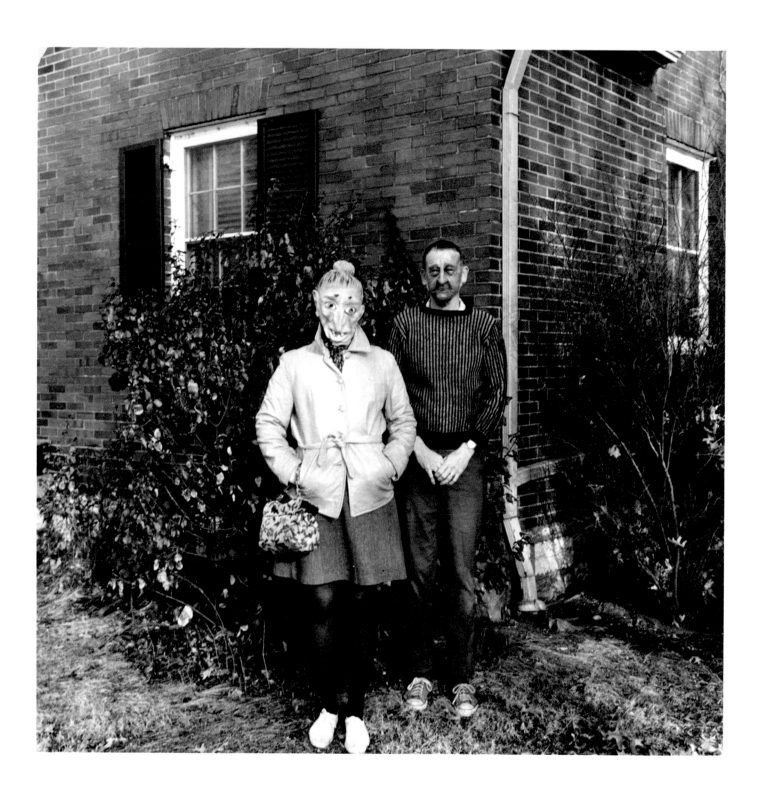

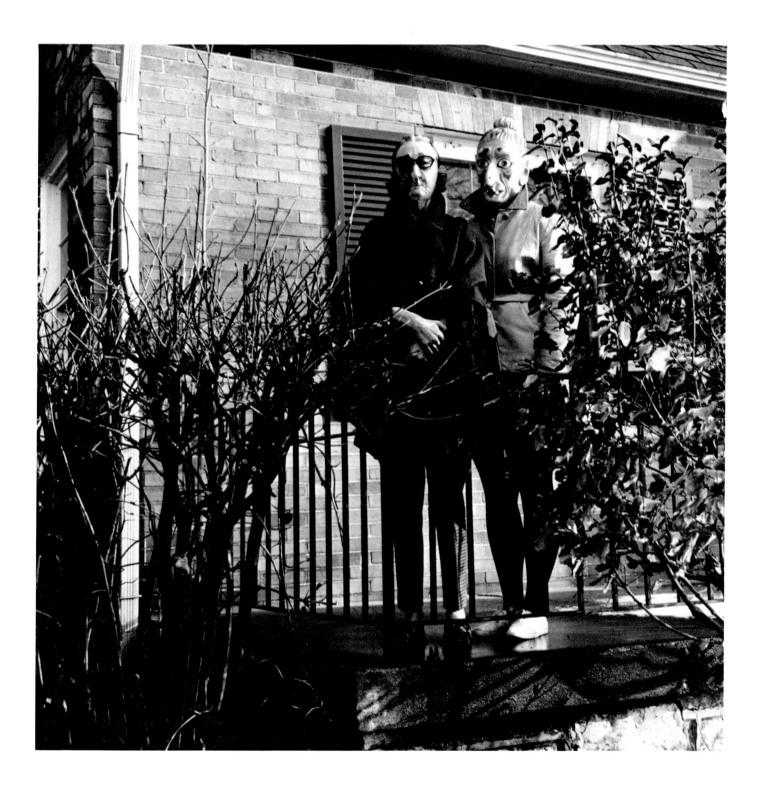

165 660

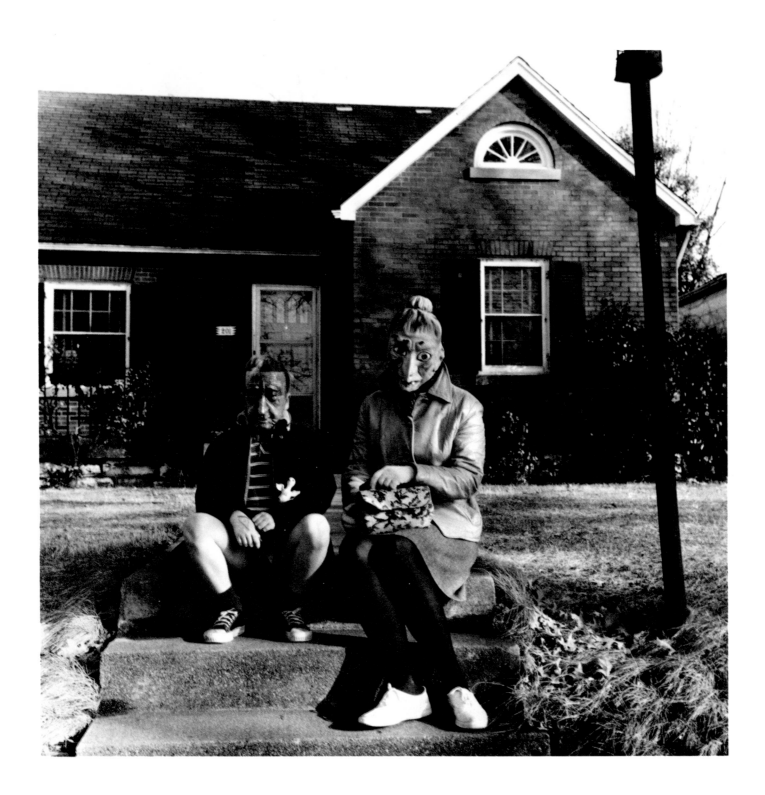

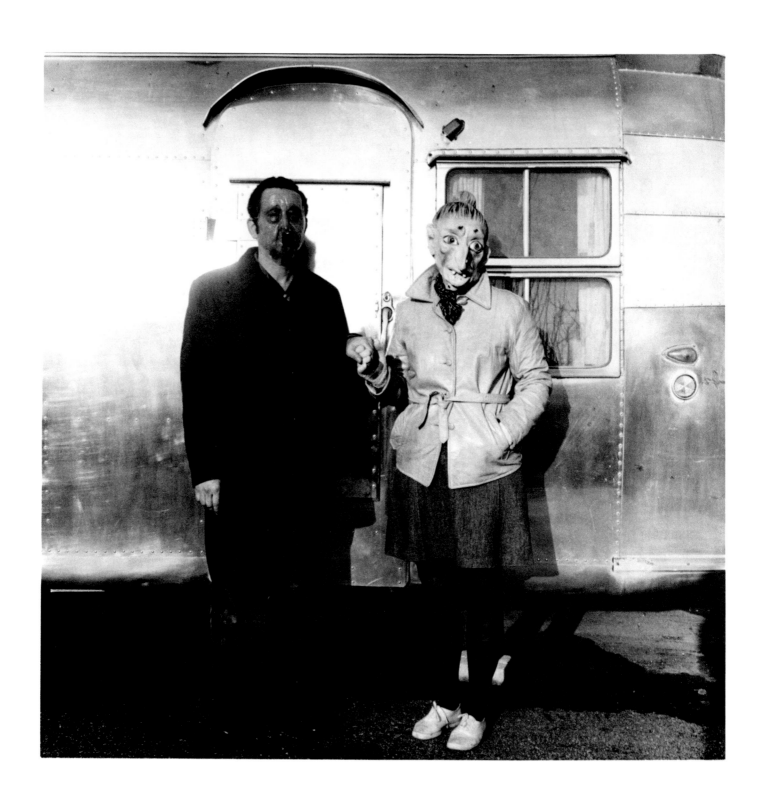

53

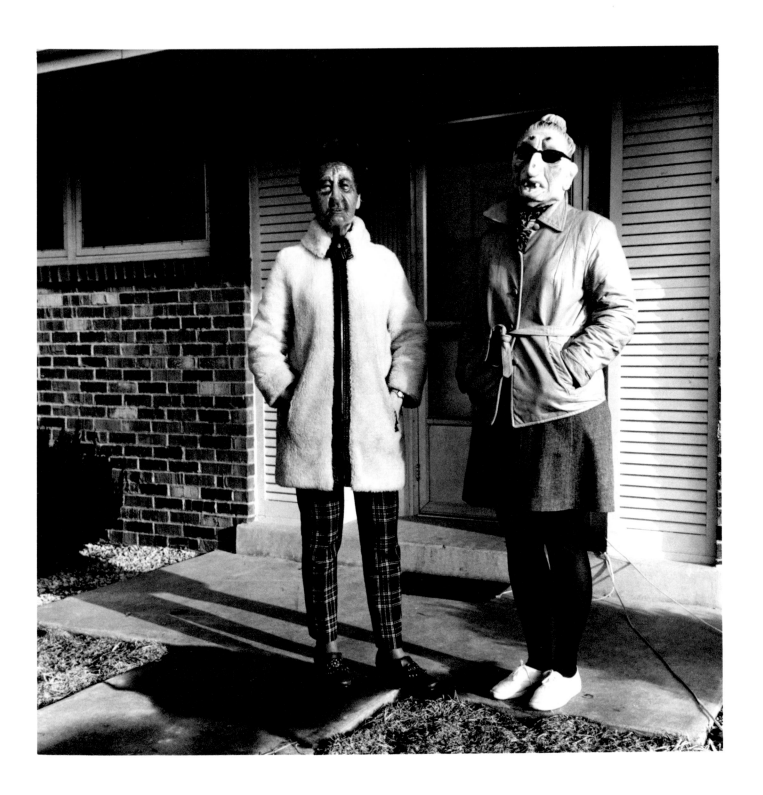

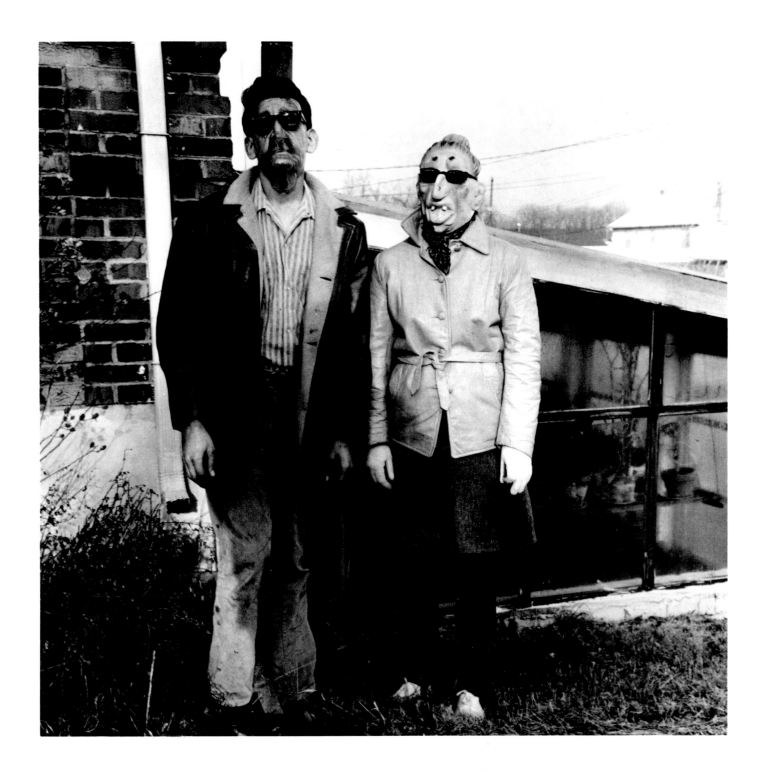

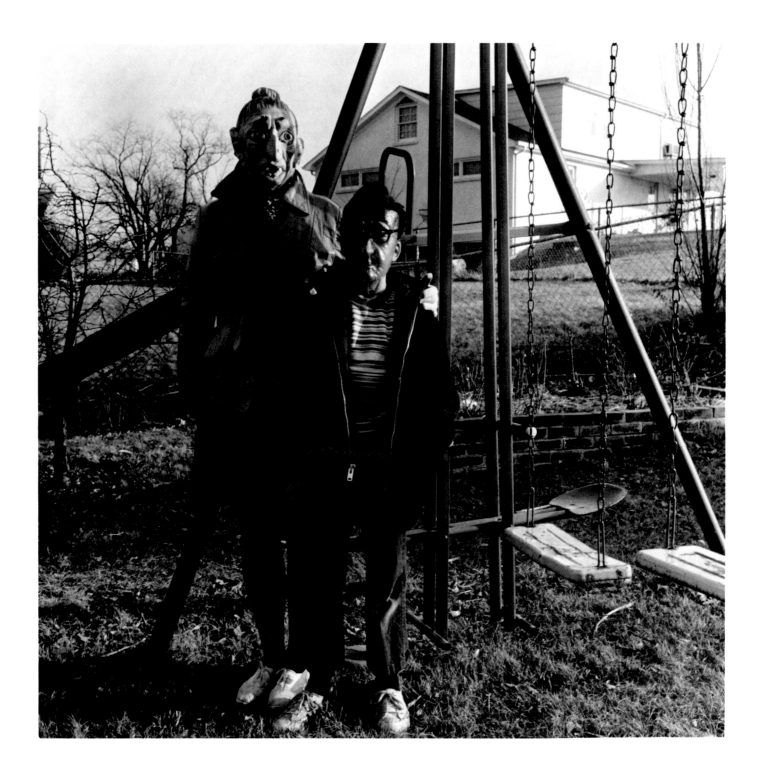

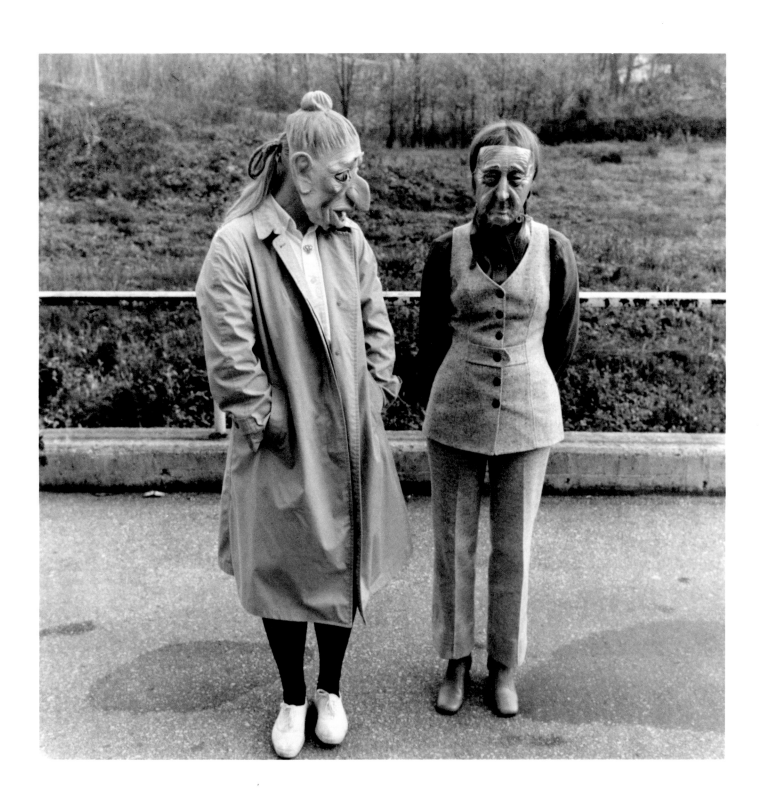

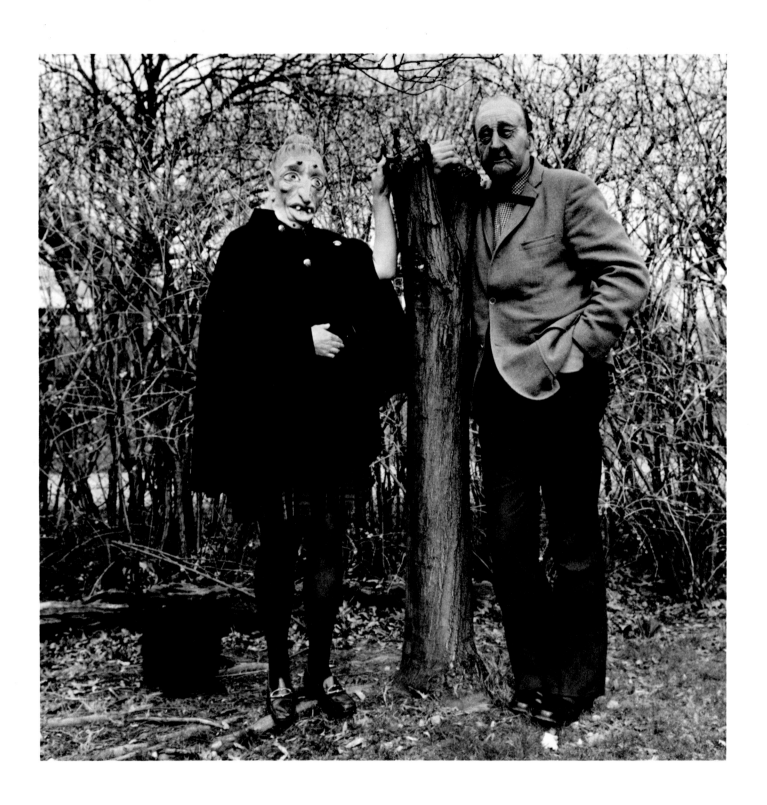

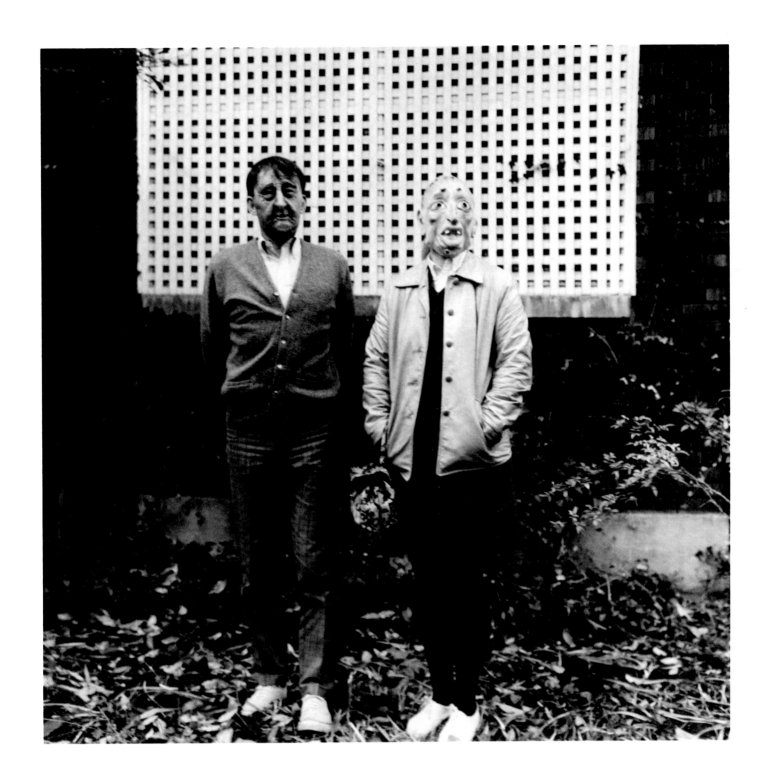

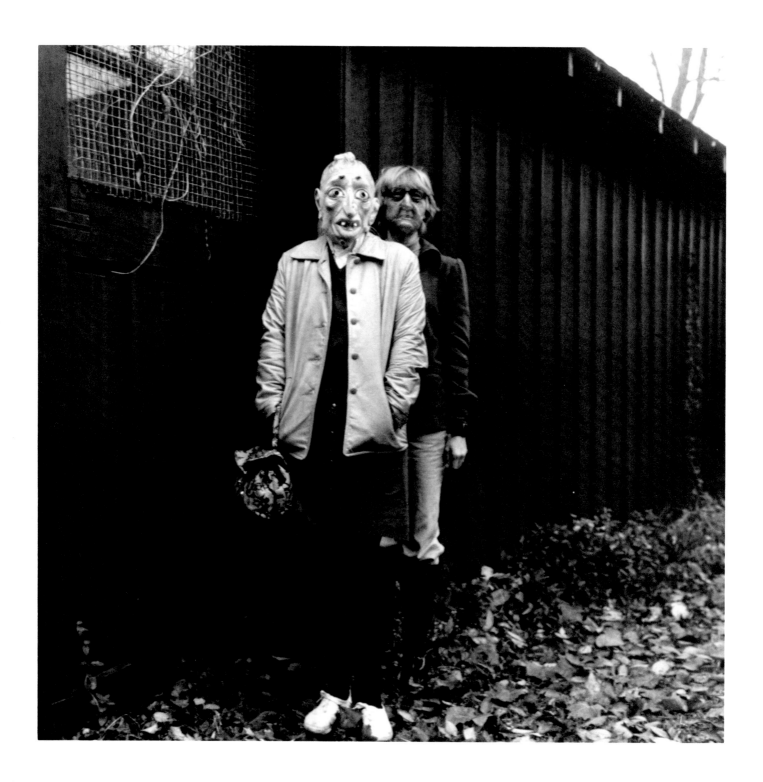

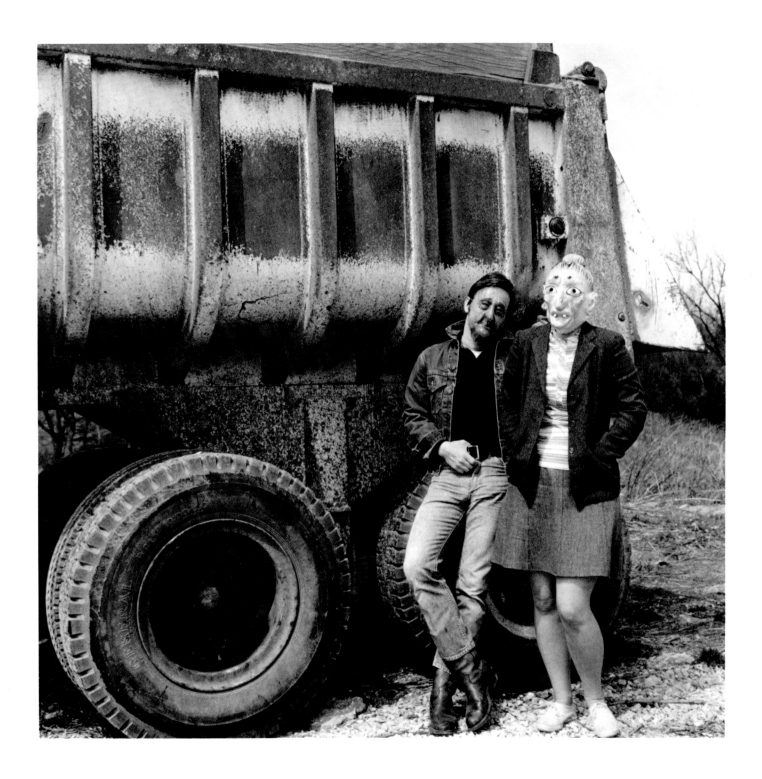

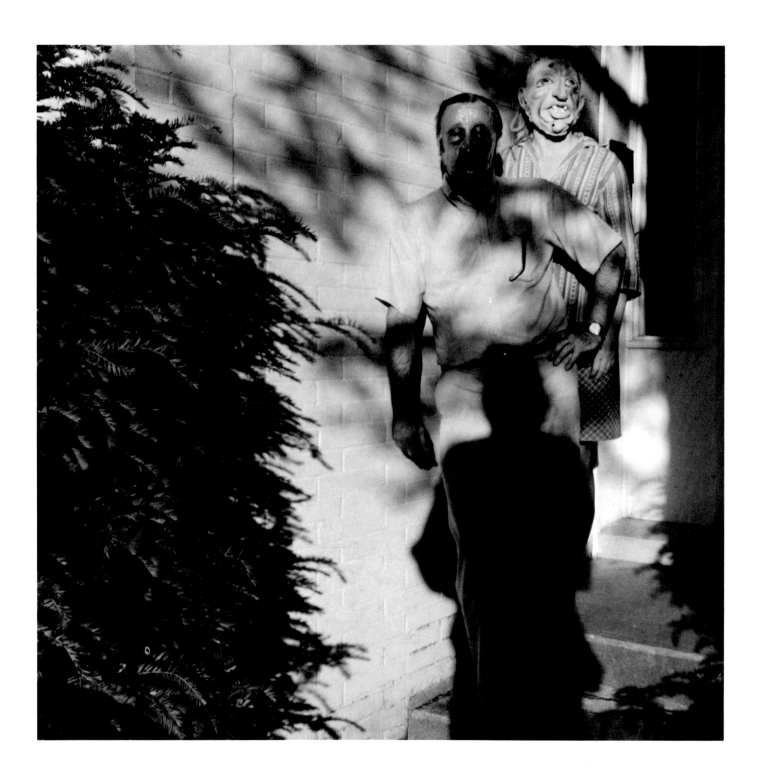

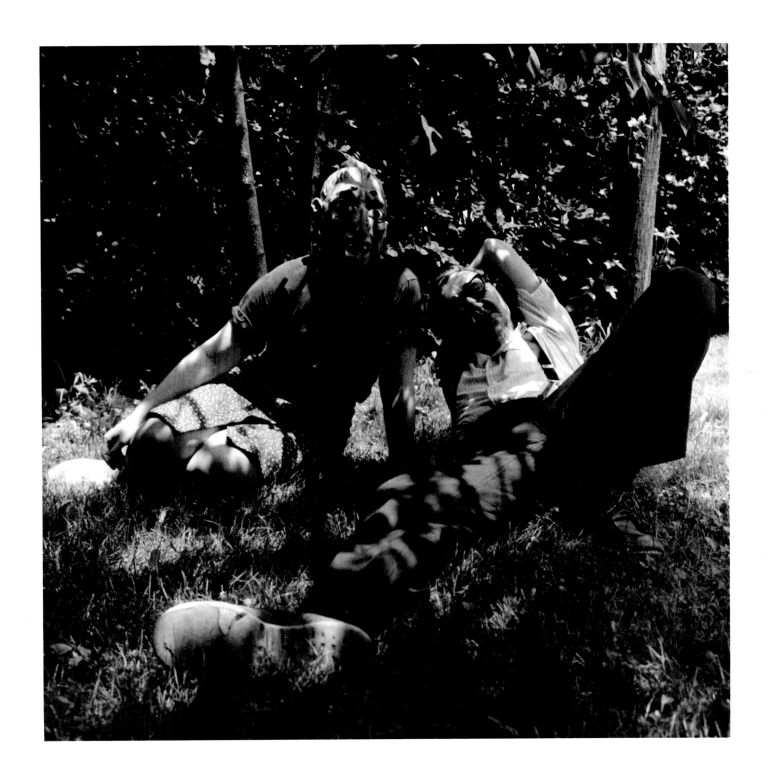

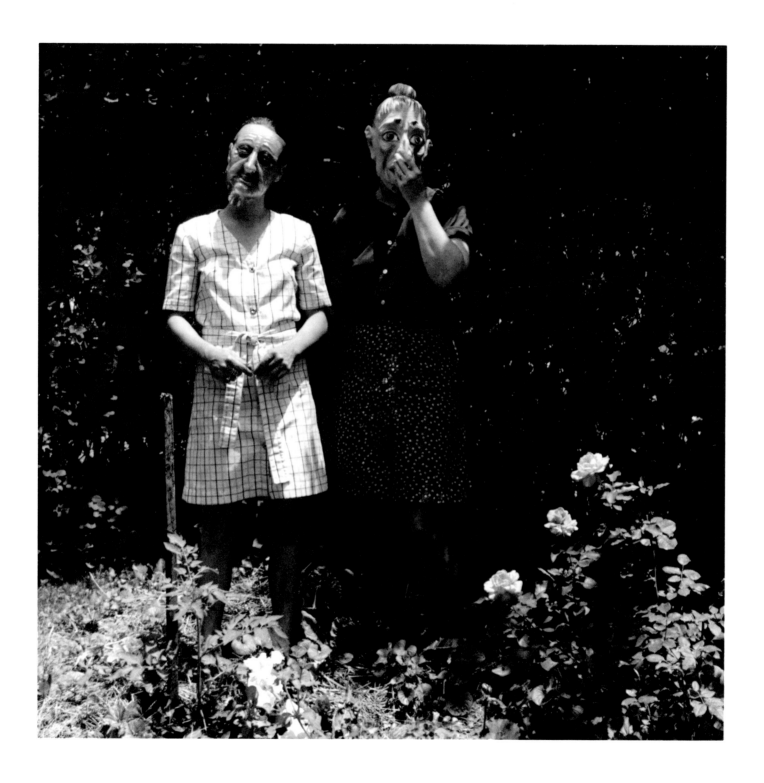

64

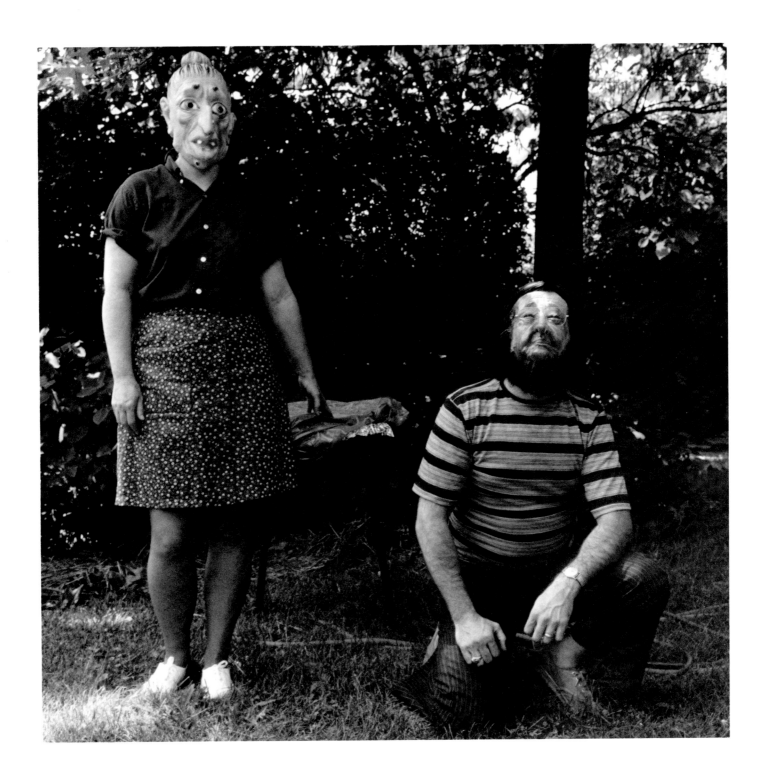

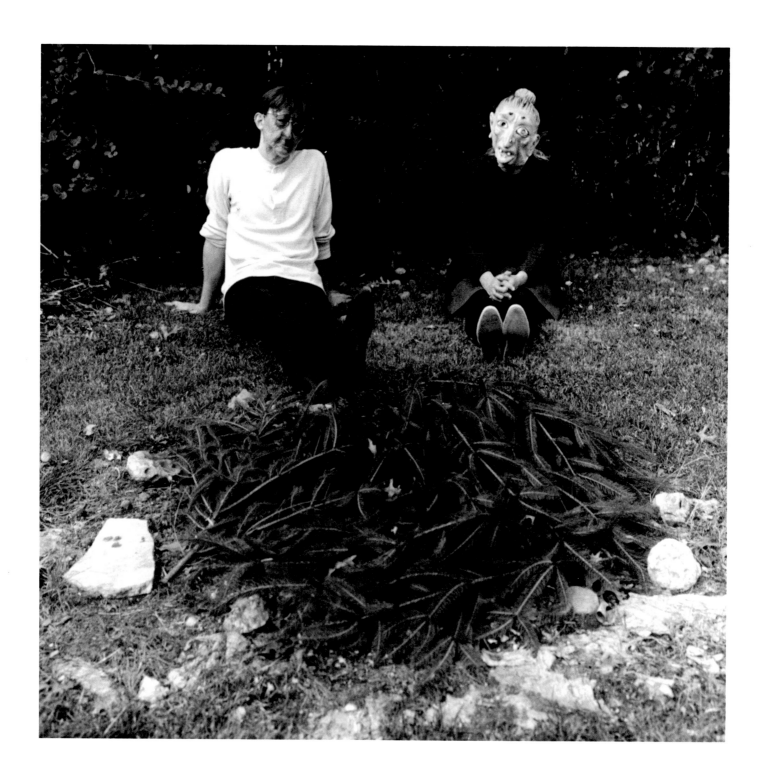

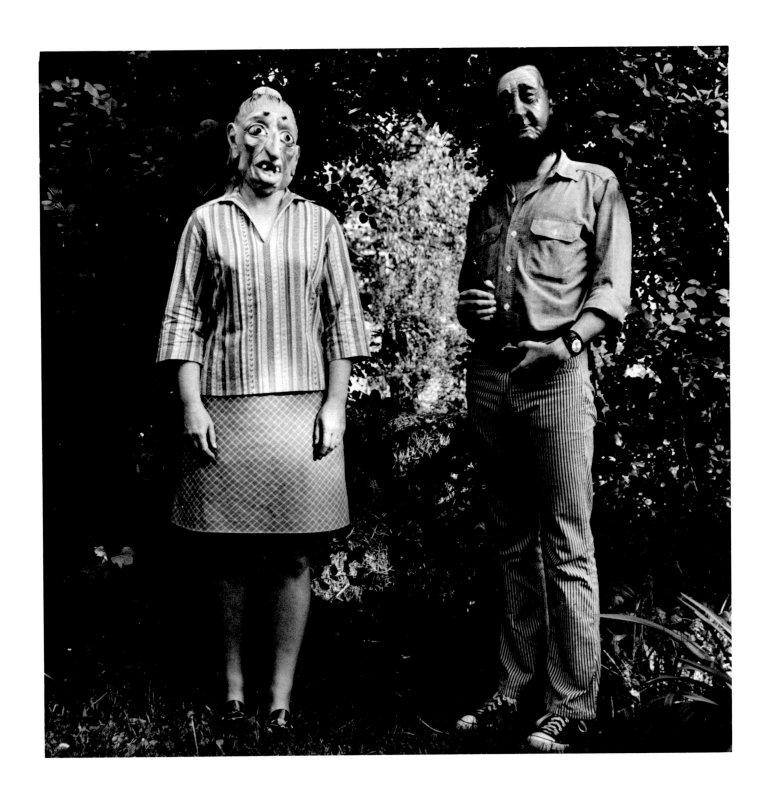

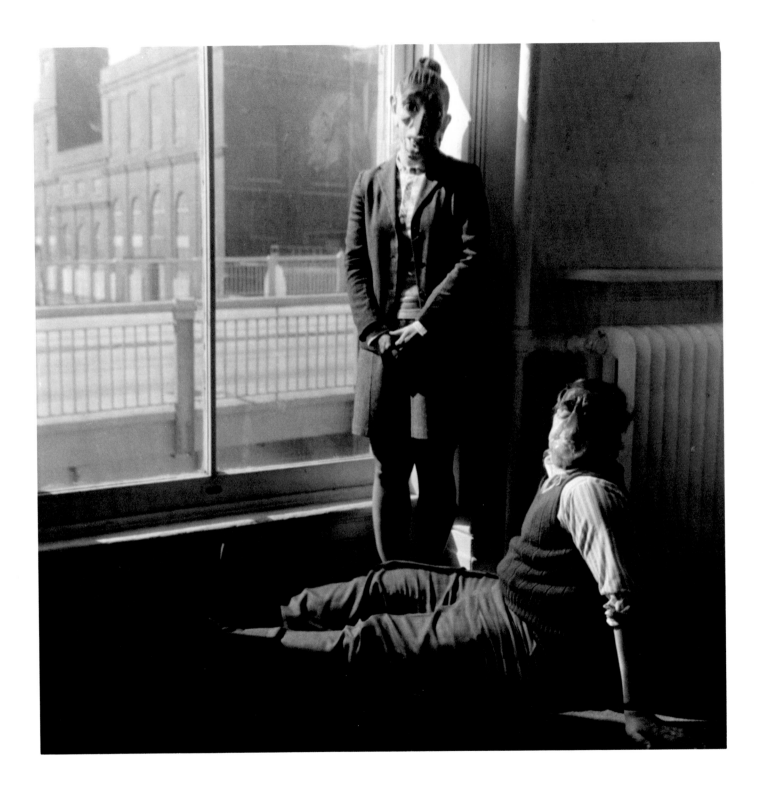

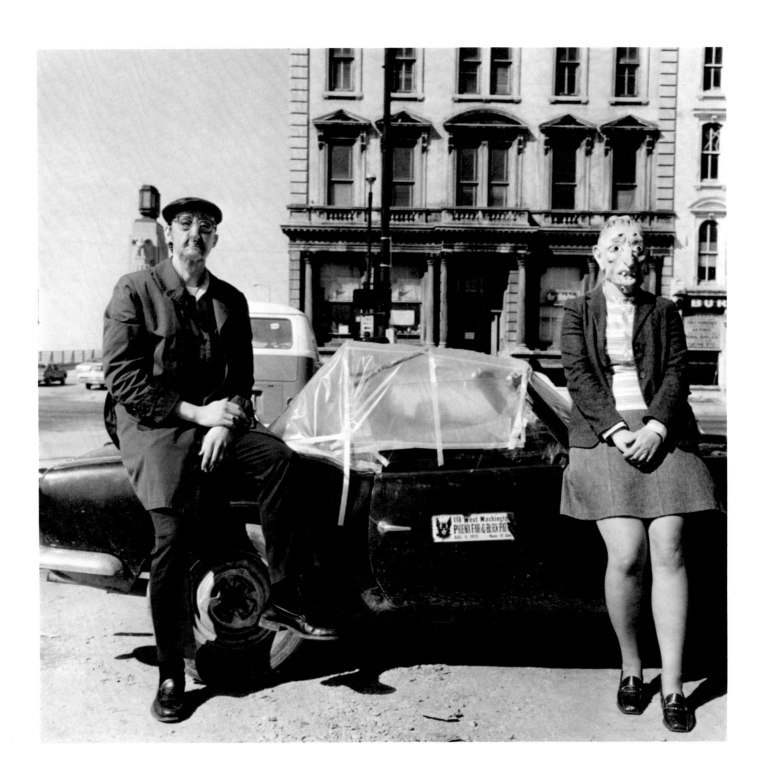

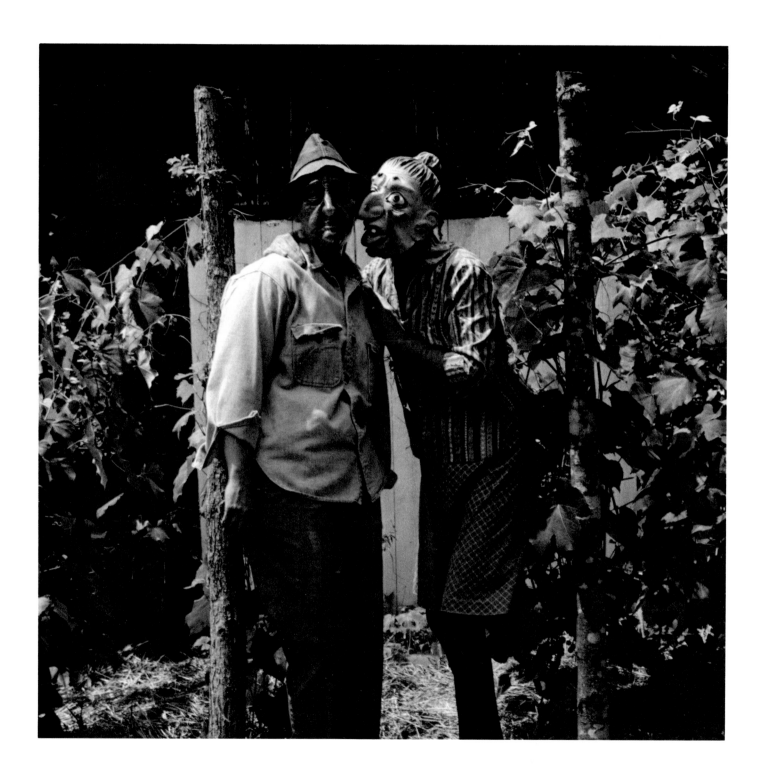

Lucybelle Crater and close friend Lucybelle Crater in the grape arbor

3 COGITATIONS

directed to Lucybelle Crater
or somebody else
with the same name . . .

In October and December 1971 and in February 1972, Gene Meatyard and I exchanged the following letters about the book in the works. Typing it all for the very last time here in an Umbrian hill village in July 1973 in the fierce light of day, I am rueful that we were too "thoughtful," as well as too cloudy. However, the substance won't hurt you, and us Southerners, like the Scarecrow of Oz, like to flex those crania when we can, just to prove we can. —JW, Polgeto, Umbertide (Perugia)

First Cogitation

JW:

There is something more hypnagogic than demagogic in proposing that, instead of sheep, one start counting 210,000,000 Americans, all with the same name, all eating at the very same time the very same interchangeable McDonald's hamburger. It is like a foretaste of the Last Judgment.

"The obvious is the very last thing we see": Wright Morris was saying that the other day apropos I forget what. It's true. It's as plain as the nose on Lucybelle Crater's face. Which nose? Lest we start getting confused, I have asked Lucybelle Crater to put on her last Ralph Eugene Meatyard mask. When I first went through the 64 prints of the *Family Album*, I began to get vibrations set up from that lady from western Pennsylvania who told us all so much about the principle of repetition. So, here—for Miss Crater or Mr. Meatyard—are three passages from lectures by Gertrude Stein. They seem to be telling us home truths:

". . . after all as I say civilization is not a very long thing, twenty-five years roll around so quickly and four times twenty-five years make a hundred years and that makes a grandfather to a granddaughter."

"What was it somebody said that the only thing God could not do was make a two-year-old mule in a minute."

"And so I am trying to tell you what doing portraits meant to me, I had to find out what it was inside any one, and by any one I meant every one I had to find out inside every one what was in them that was intrinsically exciting and I had to find out not by what they said not by what they did not by how much or how little they resembled any other one but I had to find it out by the intensity of movement that there was inside in any one of them. And of course do not forget, of course I was interested in any one. I am. Of course I am interested in any one. And in any one I must or else I must betake myself to some entirely different occupation and I do not think I will, I must find out what is moving inside them that makes them them, and I must find out how I by the thing moving excitedly inside in me can make a portrait of them."

Now, in the same way that God made little green apples, please comment on the passages. Since you are who you are, O Big Eyes of Kentucky, you can go back to the beginning of the world if you need to.

REM:

Last Judgment statement is very strong, but, Judge, the mask ain't me. I am the mask. In the final picture, as you might have partially noted, I am wearing Lucybelle's mask and clothes and she is wearing mine.

Last paragraph of Stein really fits the whole concept of minor nuances and shifts, and that there are only two people. I think I have been able to eliminate the idea of a third person: the Intruding Photographer. Natural in their own right, unlike so many portraits.

I like her (GS) short civilization depiction and feel

it blasts at the reader in the God and mule minutiae. It's a short-form civilization, broadening as idea expands into infinity. See your first paragraph. Hope you can use this. Fine here . . .

Second Cogitation

JW:

Well, to quote your old Kentucky compatriot Carlos Toadvine, I'm tickled shitless. Meaning: I hardly understand a word you say.

Miss Stein has one more thing I want to toss out: "Call anybody Paul and they get to be a Paul call anybody Alice and they get to be an Alice perhaps yes perhaps no . . ."

You know why it is so hard and perhaps so futile to write about photography, or to describe any medium in terms of another? Simply, that things are obvious or they aren't there at all. What I'd wanted us to do was air some ideas; i.e., take some ideas on a companionable walk. But, we aren't in The Open Air; we end up in The Strange. The Strange, according to Ian Hamilton Finlay in the Pentland Hills, is a place that townspeople now visit, as they used to visit The Country. Much as I love Ian and love his poems, I don't see it like that. Tonight I plan to have a dream in which Magritte, or Pa Gritte, will answer: "That was no lady, that was Lucybelle Crater!"

I am told that Magritte had an answer for those who tried to "interpret" his pictures. It was like Mallarmé's to the savants who claimed to fathom the meaning in his poems. He said: "You are more fotunate than I am." Thus, *What Does It Mean?* is not only a tiresome question, it is also absolutely beside the point . . . Magritte says another thing: "If the spectator finds that my paintings are a kind of defiance of 'common sense,' he realizes something obvious. I want nevertheless to add that for me the world is a defiance of common sense." Lucybelle, in all her wisdom, would chew on that remark and, like her friend the Tar

Baby, just say nuthin.

Again, I come back to it: how ponderous and pretentious it is to assume that one can approach "the light" in a photograph by any direction except ass-backwards or out-of-the-corner-of-the-eye. Photographic prints make no noises. I, for one, love to be mystified. (I remember a road sign in Italy, pointing to Assisi: MYSTICAL! MONUMENTAL! SUGGESTIVE!) We don't know much about anything very often, or for very long. Lucybelle who?

What Colonel Harland Sanders and the world at large probably want to know is: can Lucybelle eat fried chicken with that face? If so, how much? Answer the questions in any order you like but lay off René and Gertrude. "Strike through the mask!" Remember who said that?

After you've gummed all that with your blackgum twig and your Brown Mule, how about taking on mucky Mr. Lawrence and his notion of the Divine Couple Against The World. "They all look alike." Who does? Us or Them?

You see what I'm doing? I'm trying not to be mystified. And that's a big mistake.

REM:

Apropos 2nd paragraph, what about the person meeting another who says: "You're Paul Brown." "No, I'm Paul Smith." Or: "Alice Kline, I haven't seen you since the party." "No, I'm Alice Flem."?

I like the *obvious* statement, although some people might wish to think that they aren't there, that they will go away with time.

Lucybelle *is* everybody and, though they don't want to appear different to other people in the broad sense, the old mask forces them to assume an identity with Lucybelle. This may be taken as an ordinary family album, but it does bring in the idea that a Paul is a Paul.

Billboards in any art are the first things one sees—the masks might be interpreted as being billboards. Once you get past the billboard, then you can see into the past (forest, etc.), the present, and the future. I feel that because of "The Strange" more attention is paid to backgrounds, and that has been the essence of my photography always.

Lucybelle has never had a piece of Colonel Sanders', but if she wanted to, imagine she could eat all of it ever fried.

Striking out on the Divine Couple, we all do look alike: black, white, yellow, us/them, including the Divine Couple.

Nadezhda Mandelstam, in *Hope Against Hope*: "Is it possible that people take masks to be the means, if they discover that is the meaning, to move up in the world of art, etc?"

Third Cogitation

JW:

My wavering scrutiny begins to get like those lines of Catullus: everything is water/if you look long enough . . . Which Robert Creeley boiled down to: *It's all soup.*

In a bowl of Miss Lucybelle's southern-fried soup, I have just run into the following fortune cookies:

"Often I don't recognize faces, but I always recognize the jewellery." (Giraudoux)

"The human face is indeed, like the face of the God of some oriental theogony, a whole cluster of faces, crowded together but on different surfaces so that one does not see them all at once." (Proust)

" 'I grant you that he's not two-faced,' I said. 'But what's the use of that when the one face he has got is so peculiarly unpleasant?' " (C. P. Snow)

"There are three things I always forget. Names, faces, and—the third I can't remember." (Italo Svevo)

"I can't help feeling wary when I hear anything said about the masses. First you take their faces from 'em by calling 'em the masses, and then you accuse 'em of not having any faces." (J. B. Priestley)

"Shall we perhaps, in Purgatory, see our own faces and hear our own voices as they really were?" (C. S. Lewis)

Put on your catcher's mitt and your mask and see if any of those float in over the plate.

Say, have you seen much of Stheino, Euryale, and Medusa lately? Carlos Toadvine wrote that he thought he saw them coming out of the Opryland Reptile Gardens on Interstate 75 near Berea and that Lucybelle was with them, looking pretty damn stoned. Tell her to go easy on that Wild Irish Rosé she buys out there in the country. Carlos says it'll set you free.

I'll tell you something, good buddy. If everybody would just answer to the name of Carlos Toadvine and give in and let their hair down and look like Miss Lucybelle, we could get thishere war over with and these republicans kicked into the next county and have us a real fine country again. Remember what I say: ONE BIBLE! ONE JESUS! ONE CORNBREAD!

REM:

Very involved with several shows—no time for new photography. Not adding to Lucybelle but things will grow out of her. I have a couple of ideas to grow on.

I have these short comments to your paragraphs, by number.

3: *appropriate*; i.e., scenery, backgrounds, not faces.

4: have you read Max Picard's *The Human Face*?

5: both masks have two faces—old face maybe just one.

6: hope he likes backgrounds.

7: no, masses don't fit as I see it.

10: that's just some old hillbilly that resembles LBC.

11: right on.

This man Picard identifies everything as an image of God—but he may be right. Quote: "So sculptural does an image stand there, that it seems it ought to leave an imprint of itself in the air, and that when it has moved away, it ought still to remain visible where once it stood. Such a face wanders about the world like a perpetual seal of God, stamping His image everywhere. So pictorial is the human face, even before God, that it is as if God did not create man at all, but only saw him in a dream picture." How bout that?

THE PHOTOGRAPHER

looks at his prints and turns poet

A few weeks before his death in May 1972, Gene Meatyard gave a talk to an association of teachers of photography in Louisville, Kentucky. Much of what he talked about was the Family Album. *Reading Tom Meyer's transcription of a tape of the address, it seemed to me that its substance had been dealt with in the foregoing "3 Cogitations." However, Gene's brief remarks, as he showed the Lucybelle sequence to his audience, struck me as valuable, given proper airing, given proper available light. I have taken that linguistic responsibility upon myself.* —JW

this picture for
instance
of Lucybelle with Wendell Berry
on his farm

he raised a small crop of peanuts
which is there
in its entirety

the shadows
are my contribution
to the construction
of the picture

I find
a background

and put
content

in front
of it

the rear
of the truck

swing-ropes coming down
branch coming across

shadows on the side
of Lucybelle

there's got
to be more in a picture

than the billboard sight
we first
get

of it

in the doctor's office
the other day

people had lines running on their jaw-line
where the mask-line would come

if they were 70 years old
instead of 40 years old

how demure some
people can look

how frightened how
pleased

how this that & the other
all become

of importance

hard time
getting this little boy
to wear the mask

looks as if
he was having a hard time
doing it

the hands
on this man

add a little mask

on the play-toy they're
sitting on

how Lucybelle
raises
her eyebrows

sometimes

the toes
of this little girl

the important part
of this
particular picture

it could be you

or you or
you

you know there's a person
back there

you have no idea in the world
who

SPECTERS

and neighbors

Plus ça change, ring the atomic blocs, but we who grew in the din of New World crickets translate it

*The more it stays the same
the more it changes.*

This is Thoreau's square yard of common earth, Miss Stein's rose garlanded on itself, or Jasper Johns' target. *Anything looked at long enough becomes everything.*

We zero in on all Oz.

We have become contemporaries because we have been told again and again that everything looked at long enough becomes anything.

To make it rounder, Edward Steichen once left his camera shutter open on an apple 36 hours. At 91, he was in the midst of 15 years' photographing the same shadblow tree in his backyard. When he began it was a seedling—it has outlasted him, the first tree in history.

In time, he came to see through (and with) the tree.

His neighbors have TV sets that flicker night and day for eyes. Steichen puts out new leaves and waits for a storm in the shadblow.

As The World Turns, or as the tree sees?

Who *are* Gene Meatyard's neighbors?

Lucybelle Crater is our back-fence Gorgon: Who could look on her, but mirrored? She stands on the same real legs imagining herself over and over, with Everyman her daughter.

The Headless Horseman is a flood of nightmare; he shoulders only blind wind. The molecule took eons to learn to think, to examine itself under an electron microscope. To be headless is a dream of stone. (It is possible, some men have speculated, that what is in man's head is the sexual organ of the whole cosmological shebang—the reproductive "privates.")

Who are we when we are being Lucybelle Crater's daughter?

Nature is a mask we see through. Nature is a mask that sees through us.

Let's "face" it, the Magic Mirror Marianne Moore has held out to us, tells us, often as we question it, the outside looked at long enough *is* the inside: the essence of armadilloness defines its surface, etc.

The lines of a barn photographed by Charles Sheeler are rafters of the brain. Edward Weston's green peppers are perception per se, sweet as a new idea.

Let us believe, against all odds, surface not superficial but face. The eyes are said to be each mirrors. *Focus* the dictionary says means "fireplace"—a place of fire.

Reflection has two meanings, each the same.

"What is Art" is a riddle with many answers. Gene Meatyard poses his wife in a dime-store mask of the Mammy-Yokum-From-Outer-Space variety, and presses every itinerant poet and gravedigger he finds into a semitransparent mask like a slough from John Nance Garner. It is an unlikely answer.

Nor can you hang a thousand shadblows on your

wall. The improbable, however precise, is not often also comfortable. Sofas are sofas and art is not.

It has become art, if it *has* become art, not because he does or did it, but because he is obsessed with it. However unlikely, Meatyard has found his own answer to the riddle—and it is an answer very like a riddle itself.

"Who am I when I am being me?" says Lucybelle Crater's daughter. "Seeing is believing," answer the trees. "What is seeing?" insists the lens.

Looked at long enough, these masks reach holes in "reality"—hands to rounder apples. They hold out a hidden likeness from the page. From the aperture, appearances. Specters.

"Mirror, Mirror, in the trees—what is behind the all we see?" "Seeing is believing," knock the knees.

Art, for now, *is what pursues us*, pushes us to the brink of ourselves: the 15-year 36-hour exposure. It is at our throats.

—*Ronald Johnson*

LUCYBELLE CRATER

reminisces about his friend Lucybelle Crater

The last time I was at home with Lucybelle she had this picture made before we sat down to supper on the patio. Since then we have been apart for some time, but she has been with me constantly, as the apple is forever with its seed. She resides with me in the form of soft projections on the underside of my forehead; and as words that loose themselves from the mass of memory, slide outwards through my auditory canals and sled smoothly about in the folds of my outer ear before making the return voyage; and as warm fleshy strokes that grace my cheeks in the unconscious night when my body is inanimate as its pallet.

I remember what she told me that last time, about caring for my lover, about being gentle and always bringing strength to her and not weakness. And I remember years before, when I returned from school full of new-found conscience, she wanted to know the how and why of it, and what to say to the neighbors when they spoke badly of her child and his friends.

The clearest memory I have of her comes from much further back, though, and it makes me certain that the years will bring more understanding of things. When I was a young boy we would go to the beach and wade out to a point at which I could still stand, and she would try to teach me the art of floating. Her plumpness masked and at the same time revealed by a snug black bathing suit and her head strangely childlike in its skintight cap that buckled beneath the chin, she would assure me how easy it was—*just watch*—and fall backwards into the placid water with the grace of a huge tree. The water would gurgle softly and rush over her, briefly pooling in her eye sockets and slipping down between her breasts to

where I did not know. Almost immediately her toes, then most of her legs, would bob to the surface, and her eyes would flash open wide and gleam through water-matted lashes, and she would smile and say *you see, it's easy.*

I could never do it, though. I held my breath and stiffened my limbs, held my breath and stiffened my limbs, but inevitably my heels would start downward, soon to be followed by the rest of me, and I would end up in a submerged crouch, water in every orifice. *Just watch, just watch*, that was all she could say.

I remember, also, that I once found a length of string in the water and tied it about her waist as she floated quietly. Then, taking her in tow, I led her through the calm green that was disturbed only by my tiptoe treading and watery breathing. And she smiled into the sky as the liquid sent its fingers around her smooth head, over her shoulders, down between her bosoms and on past her buoyant legs. *That's nice*, she said.

—*Guy Mendes*

PARAFACE

(for Gene's Lucybelle book)

1. Observations of a Prop

Masks to hide, slide beyond. Not behind thee only, satanic soul-snatcher. They reveal *(click)* a narrative language. Gestures & looks unmistakable. And purer since we feel we are not really there because our faces are not in view. As if our bodies showed nothing. As if the masks were not man-made and the poses did not reveal their being.

To be *just* a prop. That can be hard work, the not-me-there being placed so the light hits just right & now once more: the head a little more to the right & tilted down, please. Or it can be quick & natural: you mean you took it already? And often if it happens quick & natural a more-true-than-life image of ourselves will come out from the mask-as-medium. But we won't admit this evidence and it is only for others to note.

So the epiphany can take place where the mask tells a truth when the gesture & face become one we all know and which by exaggeration becomes known more easily.

2. Lucybelle

Hick hills hello. And some sub-bourbon. Tennis sneakers can't spell so good, but sure knows how to do up the hair & make that face (ain't Lucy*belle* for nothin'). And talks, Lord she talks & gossips much as Ole Elviney in Snuffy Smith, I mean she'd make a waterfall rise upwards & go home to get away from it. And now with these telephone contraptions, I get a cramp in my neck after she lets the first word fly. Seems she only sits quiet when she's having her picture took.

Above the heads of Lucybelle & friends, there floats

a comic-strip bubble that is pure virgin white for us to fill in with snatches of Murkn life, like second-guessing the neighbor you're feuding with, that it be as sententious as the rebuttal you were not quick enough to think of when you were having words but hope to save for the next time you meet. But actually our Lucybelle is the friendly sort & meets up with all sorts of friends, like poets looking like teenagers or grandfathers & then some, or a young'un looking like a gnome or grandfather & then again some.

So beyond the automobile graveyards proving the 20th century is existential fact, there is a heart in Lucybelle no food stamps can feed. And that, my dear friends, is why all these fine people gather round and someday, yes someday, some confused anthropologist/critic type will wonder how such creatures came to exist. For while some are watching football on TV and others are doing what they do at drive-ins, all this exits also and is part of an arcane subculture taking root in someone's head. This someone happens to live in Lexington, Kentucky, and lives in a most placid neighborhood. Which is to say there might be a Russian spy, a writer or a photographer living next-door to you, Mr. & Mrs. Heartland, and the world he is in may prove very strange. So watch out! Or get curious and seek out our Lucybelle. She may hug you, more than likely will talk up a storm . . . perhaps you'll even get your picture took with her by your side.

—Jonathan Greene

MASKS

for faces*

Mask once meant "specter" (. . . maybe). Here in Polgeto, in Umbria, all the *contadini* wear the masks Piero painted them with. Or so my eyes have it. I sit in the strong mountain light listening to a tape of Gene Meatyard. I tan & see the sun incise a line where the edge of my briefs stretch over my groin. Then walking into the bedroom I turn & see a specter. My heart skips its beat & my eyes focus to pick out the "actual" event: a mirror (full-length) hung in the closet & a reflection of me masked with a heavy northern Italian tan—the whites of my eyes gleam. They flash like lights through a second, unfamiliar, specter face.

I see that same look in the eyes of these Umbri when my smattering of Italian breaks down, when I understand nothing they say to me & they understand nothing I say to them. *Io non parlo italiano*, all talk breaks down. My inability to speak Italian stops me but their eyes stop me as well, the way they look out wondering what the *americano* asks them. I see specters, masks from frescoes.

I sit in the strong mountain light listening to a tape of Gene Meatyard. He explains, comments, describes, ruminates & answers questions as he shows slides from *The Family Album of Lucybelle Crater*. Certain haunting memories, clear images focus behind my eyes. No more than 5 or 6 of the photographs from the series. Yet in those few I see what I thought I saw looking through the whole series: specters.

Held before the eyes: strange faces & familiar attitudes set against homely backgrounds (backyards, suburban streets, fences, front doors).

My voice stops. Stops the way it stopped inside me when I caught myself unawares in the mirror. Stops the way it stopped when I had no way to tell the man at the door that *la signora* comes back from Firenze

about noon. My voice stops & my eyes start. Start to see the look on my face, the specter there. Start to see the look on the deliveryman's face.

Someone in the audience asks:

Why the grotesque mask for Lucybelle?

Gene Meatyard answers:

To make Lucybelle Crater a grotesque person . . .

He wanted to identify her in another way from the second person in each photograph, that other one wearing the mask of an old person.

Grotesque, but not grotesque; *different*. Strikingly different, grotesque, say, the first 10 times you see it. Then, slowly Lucybelle looks (by the eleventh or twelfth picture) just different, no longer grotesque. (That word *grotesque* comes to English through French from Old Italian. It refers to the painting of grottoes. Italy again & oddly enough, tucked away in *grotesque*, lies an apt metaphor: the grotto, at first dark & forbidding, which yields shade from the sun & cool relief once explored.)

& that other one wearing the mask of an old person? Well, different from Lucybelle & different in each photograph, looking old each time—no matter who lurks behind those plastic, transparent wrinkles. So, 2 constants, one of which changes attitude each time & the second of which changes persona each time . . .

Or so I think, tempted to pull into words some explanation as to why these photographs leave me speechless. Like seeing a ghost. Not, no, not the fear of that vision but the silence, the *io non parlo*. Why? I ask myself, me of all people? Me, imagine it, a chatterbox willing to say anything about anything, & I draw a blank before this album.

*Shakespeare, The Winter's Tale, IV, iv.

Last November I looked through the family album of the man in Yorkshire who fixes our broken pipes, hedges the lane & looks after the cottage when we go away. I said all kinds of things, picked out the few familiar faces, asked where they stood & who owned the caravan.

Yet leafing through Lucybelle's album I have nothing to say, just something to see. I wonder if Gene Meatyard somehow slashed all "verbals" from these pictures despite the titles, the literary illusions. I know he felt photography's major alliance lay outside the visual & within the verbal. But I wonder if Lucybelle's album operates itself as a nonliterary & totally visual object set within that familiar context that always gives rise to speech: the family album. The most natural response before a book of snapshots— the pleasant chatter & the memories—vanishes. I find myself not even wanting to know who's wearing the masks. Something about the attitudes, the arms, the eyes half-seen, the heads' angles holds all my attention.

Explaining a little about his work, Gene Meatyard says:

I want to get people to read stone, tree, so forth & so on through the construction of the picture, to lead them to see these things exactly as if it were written out on a page. I think it can be done.

The spookiness of these photographs, I think, comes from their lack of narrative. Or at least their lack of that specific narrative a snapshot has for a member of the family snapped. The story this series has to tell lies in the subtle differences of a single situation repeated & repeated: Lucybelle Crater & Lucybelle Crater. The same each time, yet each time absolutely different.

Odd how that spooky quality (for me at least) begins to bend into fascination & then into familiarity—a human warmth. As if the masks, the specters, work like Piero's perspectives & lead my eyes deeper into the picture, around corners past various things

set in my eyes' way to read as I go back to that green patch & grotto, there where the cloud makes a shadow.

On the tape Gene Meatyard tells his audience seated in a camera obscura:

> No intention of any dramatic things out of the shadows, but making the shadows lead into a picture & carry its balance, carry its weight, making the shadow of Lucy stand out more.

The sun shifts slightly, I snap off the tape, lift the blanket & set it down again. The smell of thyme heavy on the air, newly crushed by my shifting to the sun's new angle.

Tape on again. Gene Meatyard's voice to me, to the black cat stretched out on the terrace, to the olives with their glinting top leaves:

> Am I looking at a mask or am I the mask being looked at?

—*Thomas Meyer*

Lucybelle Crater—Mrs. R. E. (Madelyn) Meatyard